YOGA AND THE CITY

YOGA AND THE CITY

ALEXEY WIND

goff
BOOKS

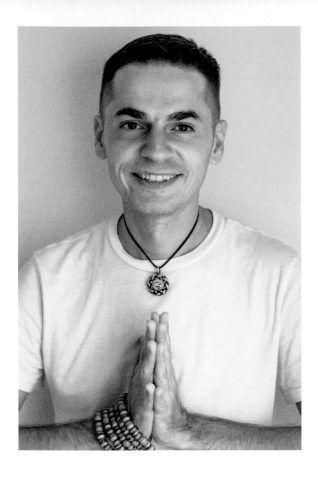

ALEXEY WIND

Los Angeles, USA

Born November 11, 1983 in Kamchatka, Russia, Alexey Wind moved from Russia to the USA in 2010, where he started his art career. Since moving to the US, he has created and participated in a variety of art and creative projects, has taken part in various exhibitions, and has done solo shows.

Currently, Alexey lives in Los Angeles. Besides the *Yoga and the City* photo project he is also involved in other art projects including the "Naked" show at the Soho Photo Gallery in New York in 2016, a solo show called "Play" at the Center of Contemporary Art Winzawod in Moscow in 2015, and a group show at the Avant Gallery during Art Basel in Miami in 2015. Other works are exhibited widely in many art galleries around the world.

Alexey now teaches yoga and meditation and continues to travel and inspire. *Yoga and the City* is an ongoing project that Alexey continues to add to as he travels around the world meeting new people who practice yoga. To follow the *Yoga and the City* project follow on Instagram @yoga_and_the_city, or for more information on Alexey and his work visit his website at www.AlexeyWind.com.

INTRODUCTION

Living in a big city, it's very easy to loose oneself in the constant running after values and dreams that don't even belong to us. Big cities are like a melting pot of everyone and everything, where we face a mix of cultures, traditions, lifestyles, opinions, and values. How does one stay true to oneself in this ocean of thoughts and ideas? One has to know who he or she really is. One also has to be strong and should never stop his or her spiritual growth. This is what I want to reflect in my project.

More than a year ago I went on a round-the-world trip, during which I met yogis around the world and took pictures in different cities and countries. This is how I started my work on the photo project *Yoga and the City*.

Through my project *Yoga and the City* I wanted to capture people who are committed to the yoga philosophy and yoga lifestyle in big cities; people who manage, living in the middle of all the hustle, to maintain their harmony and happiness. It doesn't matter what is surrounding you. What really matters is how you look at everything around you. *Yoga and the City* combines art, spirituality, and fitness. It is a reflection of a person's strength and power to overcome adversity and to find balance while living in a fast paced environment. Yoga is a way to find alignment with your true self, to become closer to your spiritual core. When you see my images you may decide to start doing yoga, or try meditation. Maybe you will quit the job you don't like and finally start doing something you have been dreaming of for a long time. Maybe you will go on a long journey.

My advice to all people out there is to follow your path and your soul's calling. Do what you love, and do it with passion. We live in a beautiful and unique world, and we shouldn't lose ourselves in the everyday routine and hustle, but must keep enjoying this life and every moment of it. This is what my project is all about.

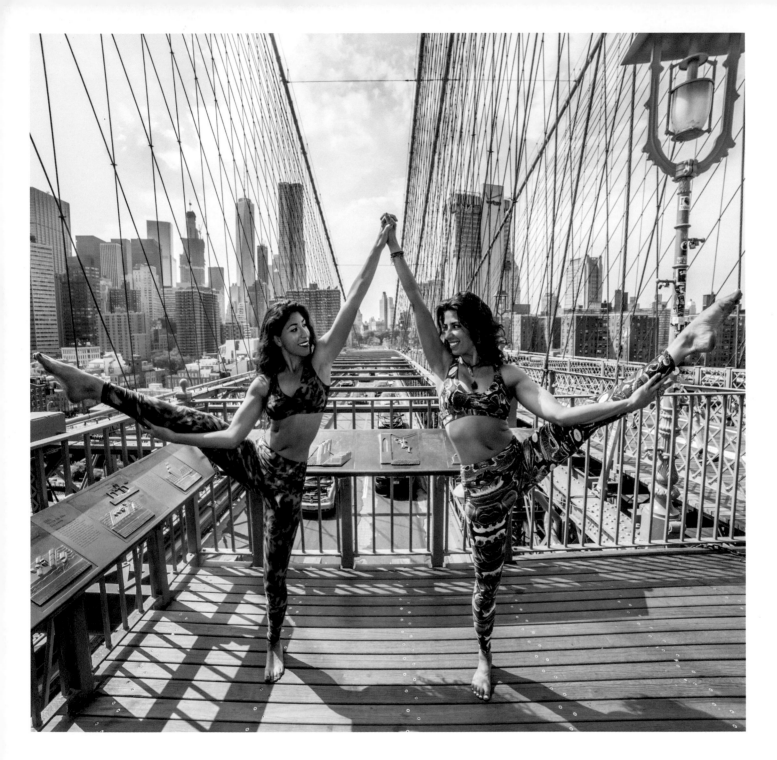

Surround yourself with people who encourage you,
inspire you, and believe in your dreams ROY T. BENNETT

NEW YORK

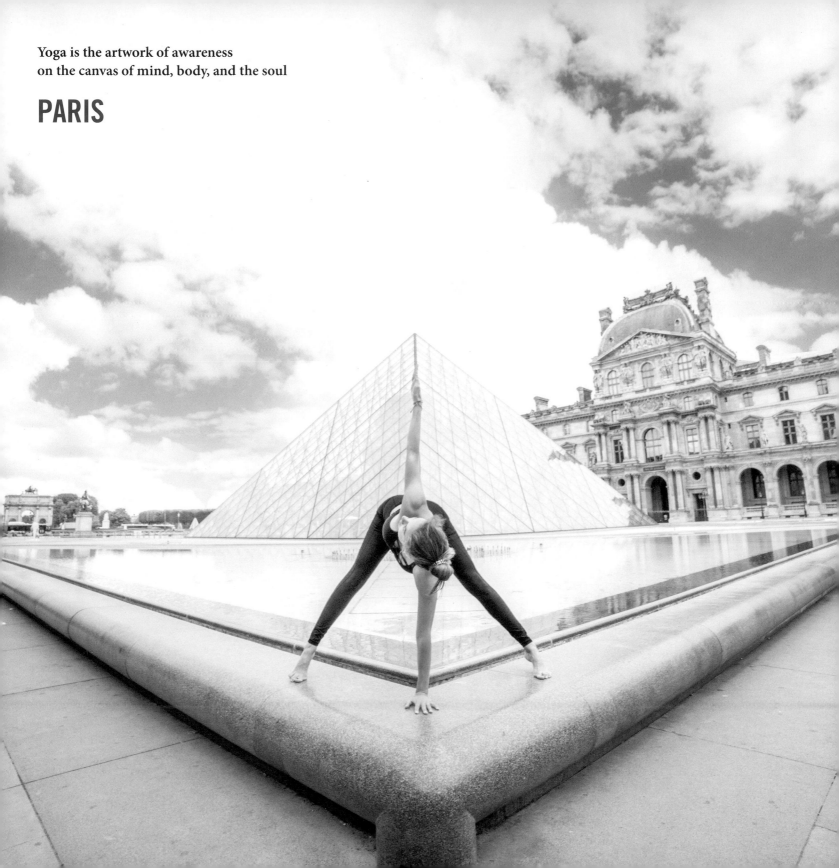

Yoga is the artwork of awareness
on the canvas of mind, body, and the soul

PARIS

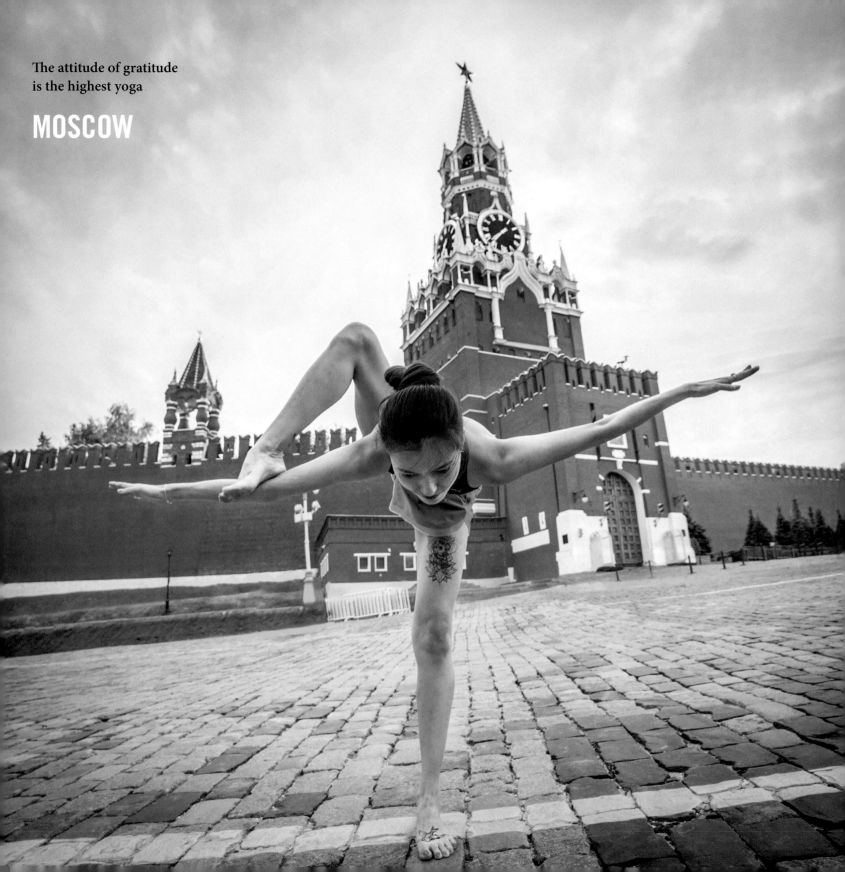

The attitude of gratitude
is the highest yoga

MOSCOW

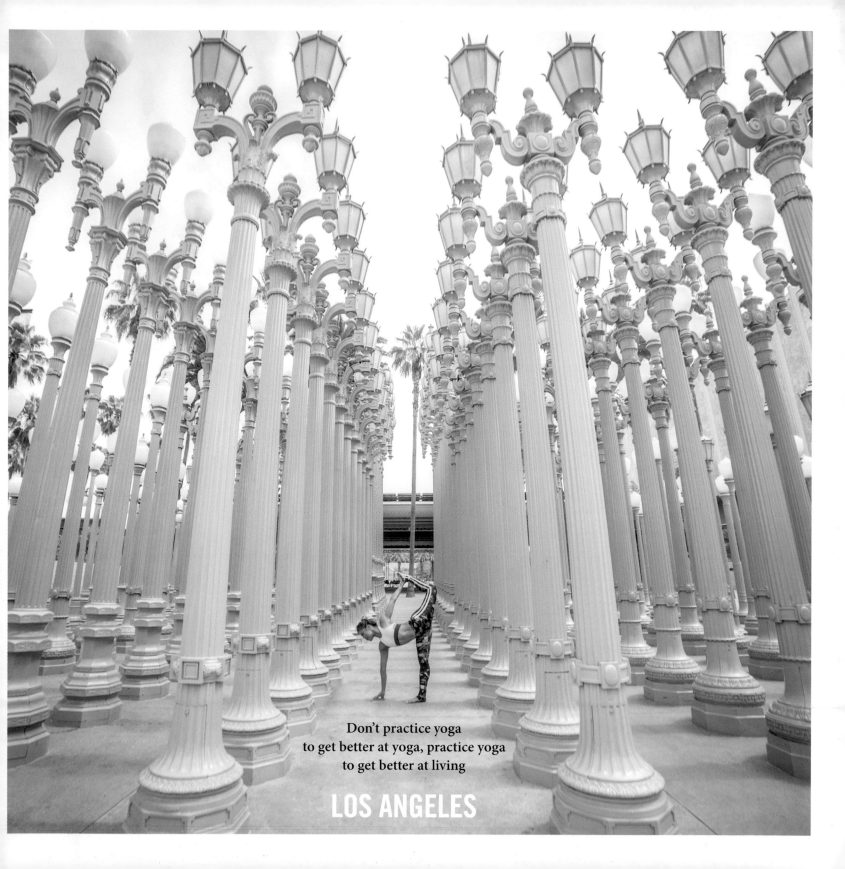

Don't practice yoga
to get better at yoga, practice yoga
to get better at living

LOS ANGELES

Your value doesn't decrease based
on someone's inability to see your worth

ROME

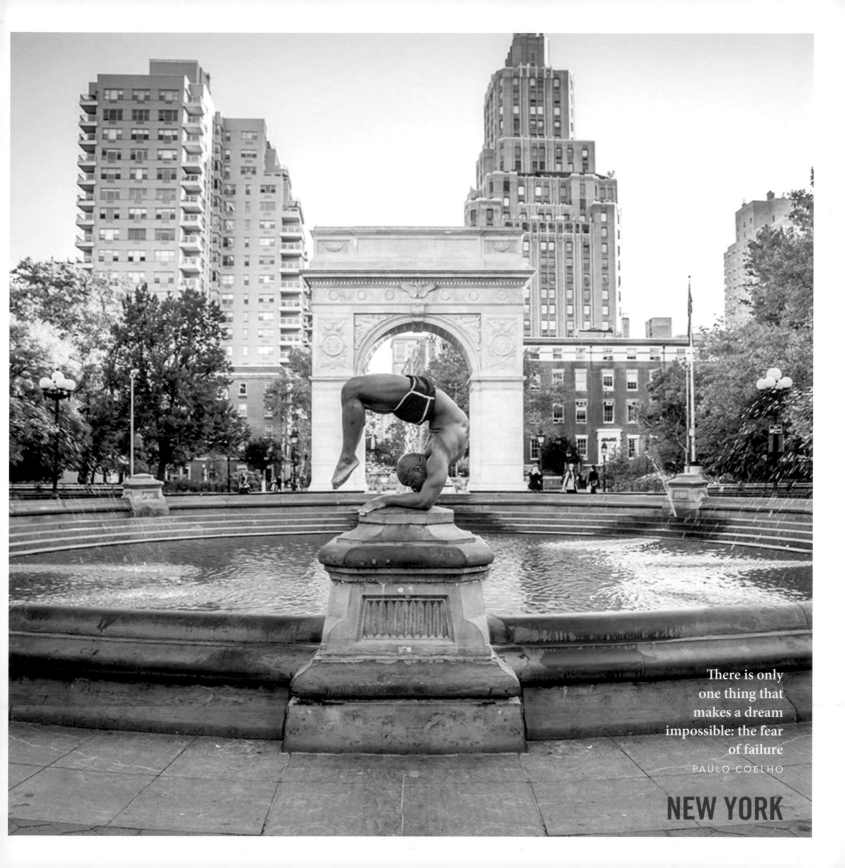

There is only
one thing that
makes a dream
impossible: the fear
of failure
PAULO COELHO

NEW YORK

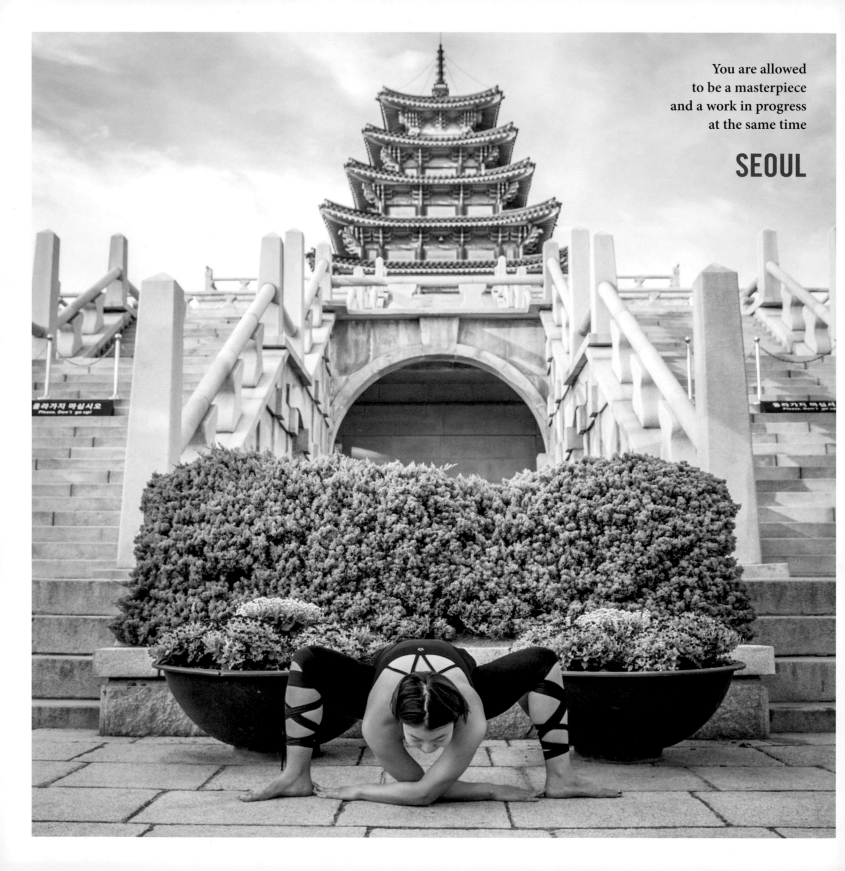

You are allowed
to be a masterpiece
and a work in progress
at the same time

SEOUL

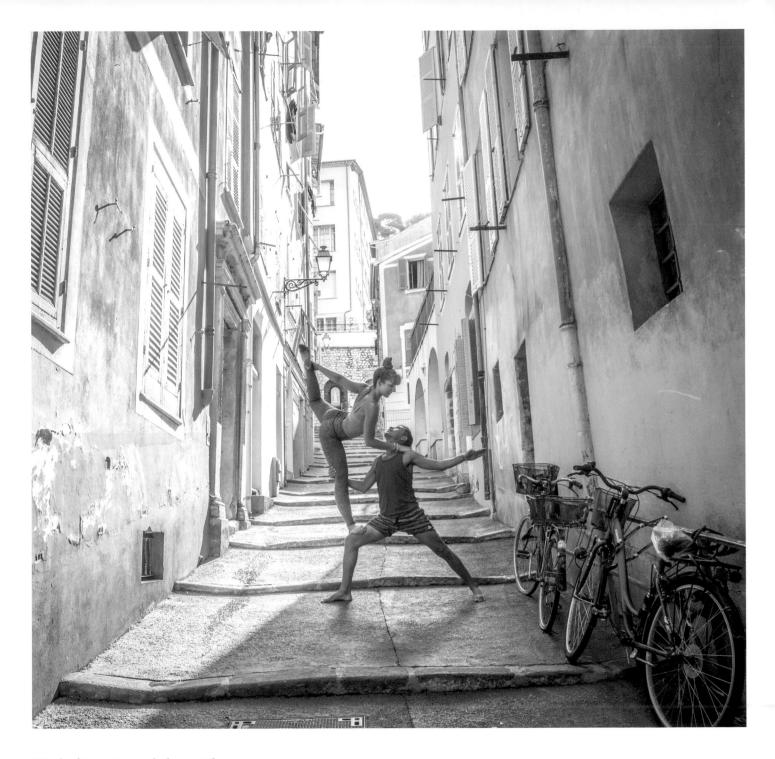

We don't meet people by accident
they are meant to cross our path for a reason

NICE

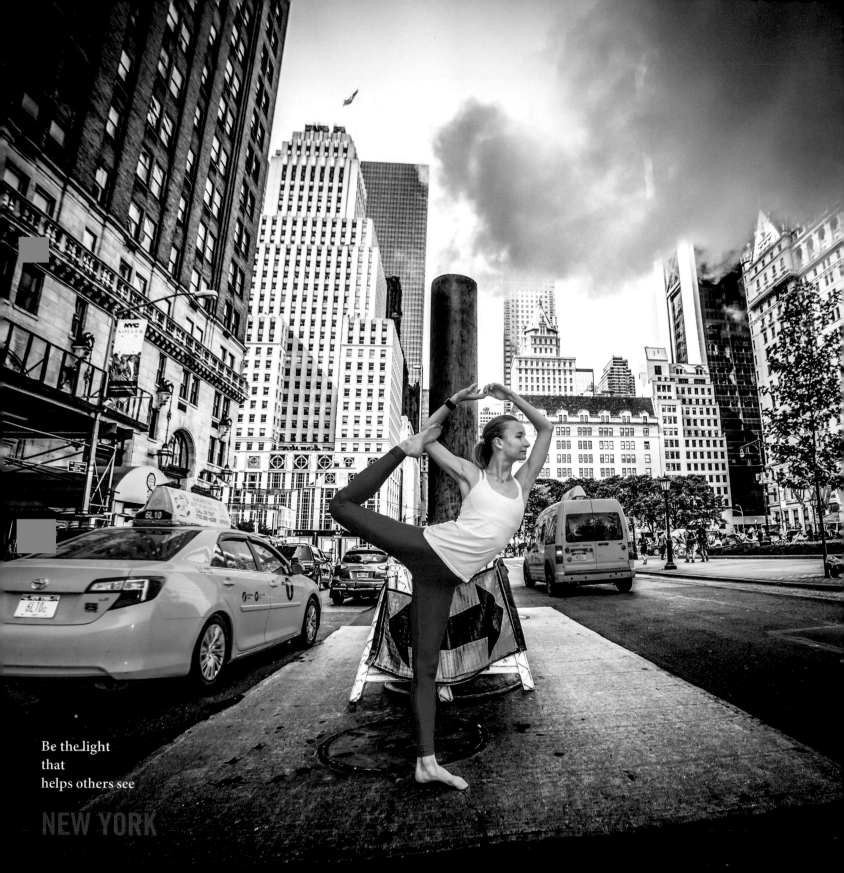

Be the light
that
helps others see

NEW YORK

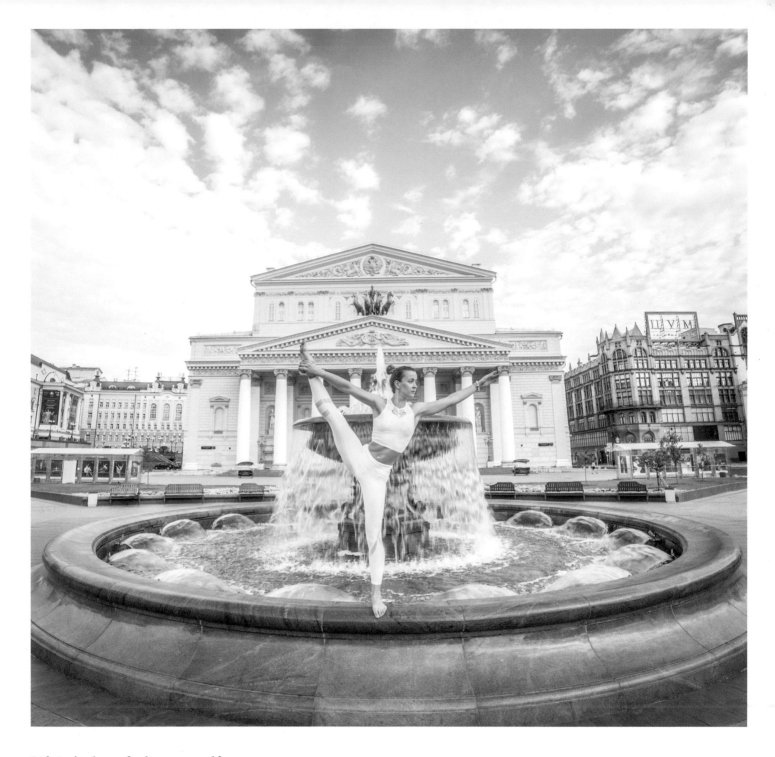

Life isn't about finding yourself.
Life is about creating yourself GEORGE BERNARD SHAW

MOSCOW

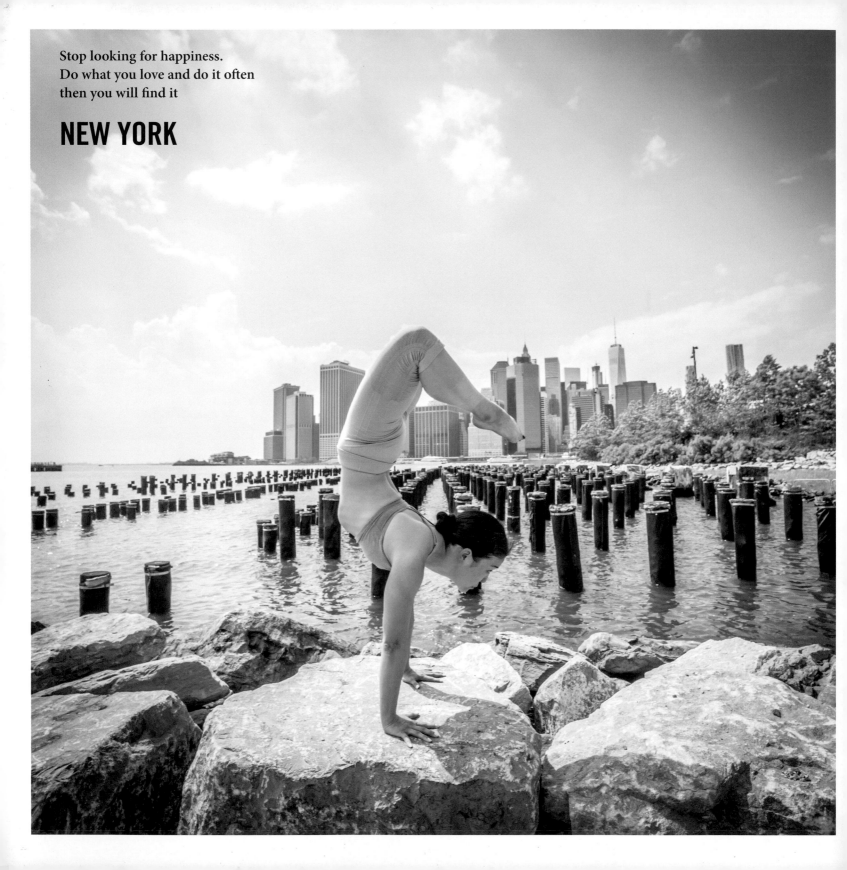

Stop looking for happiness.
Do what you love and do it often
then you will find it

NEW YORK

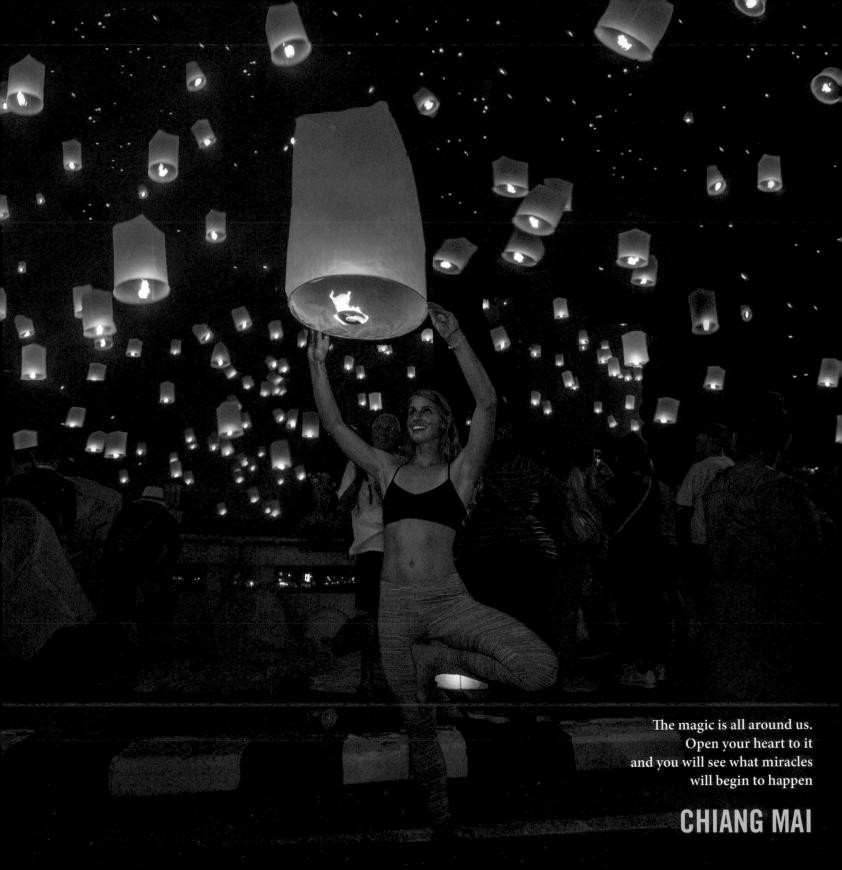

The magic is all around us.
Open your heart to it
and you will see what miracles
will begin to happen

CHIANG MAI

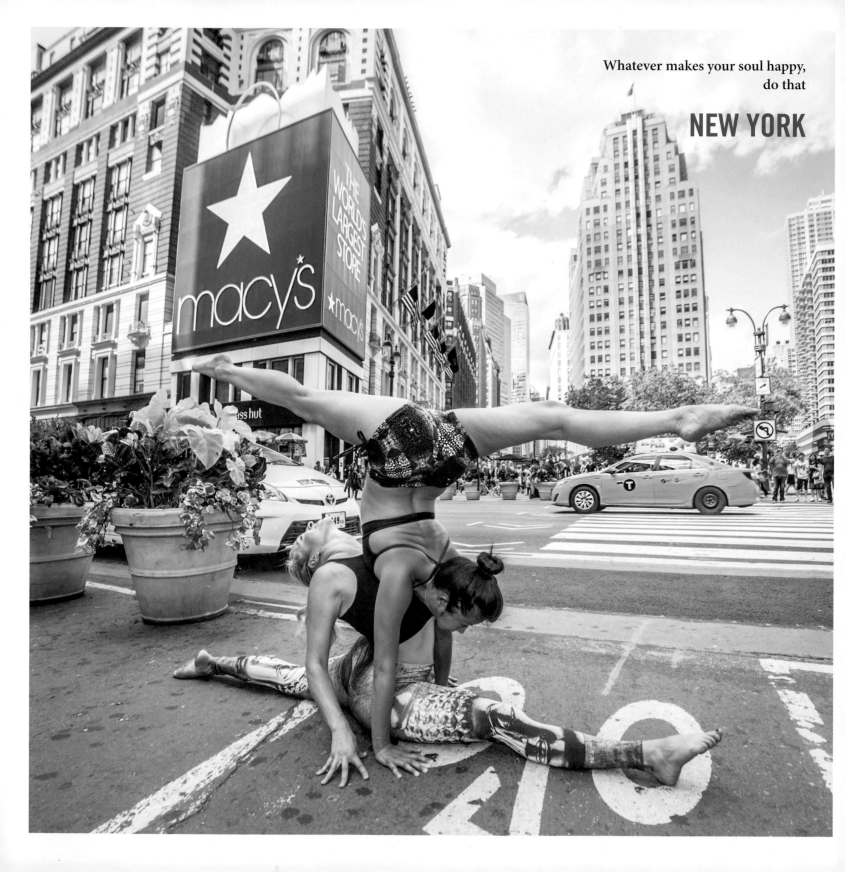

Whatever makes your soul happy,
do that

NEW YORK

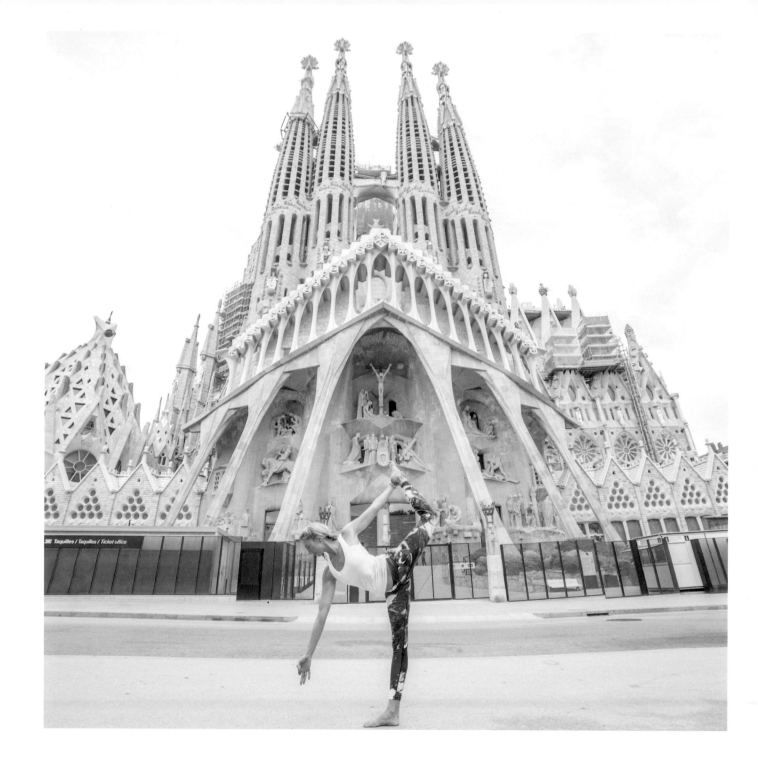

Yoga is the perfect opportunity to be curious about who you are

BARCELONA

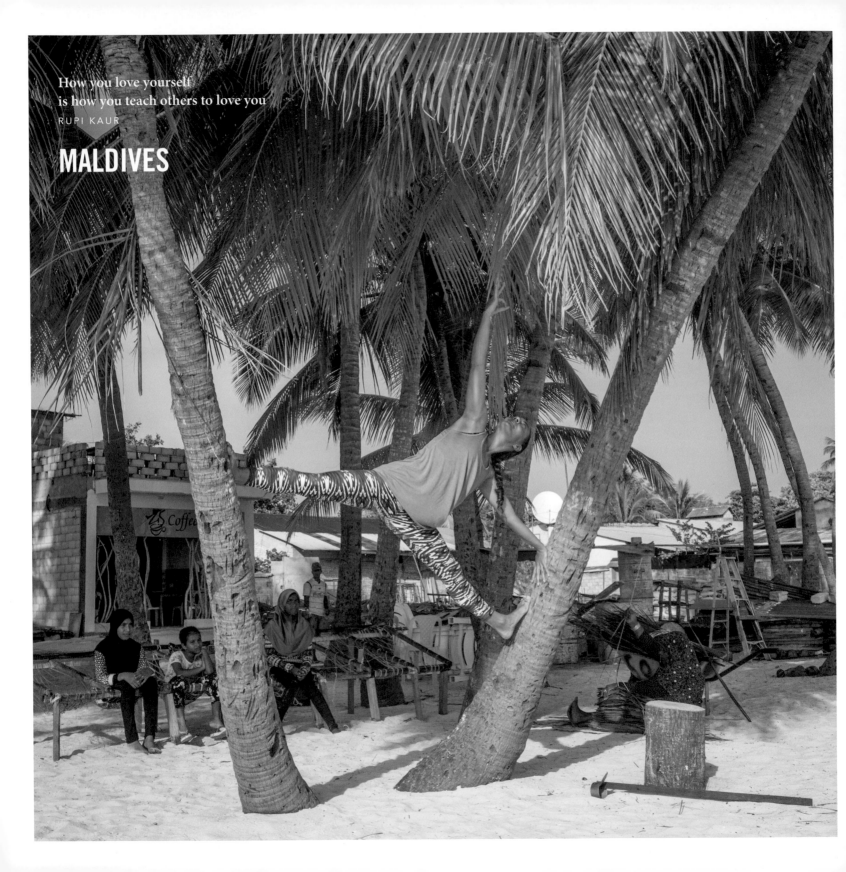

How you love yourself
is how you teach others to love you
RUPI KAUR

MALDIVES

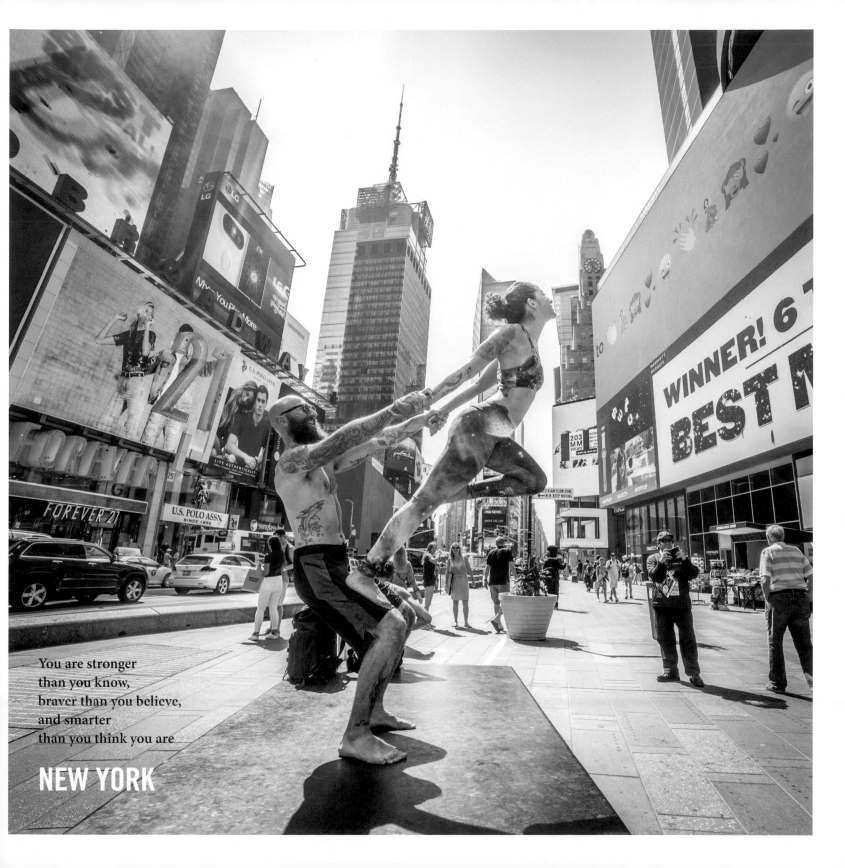

You are stronger
than you know,
braver than you believe,
and smarter
than you think you are

NEW YORK

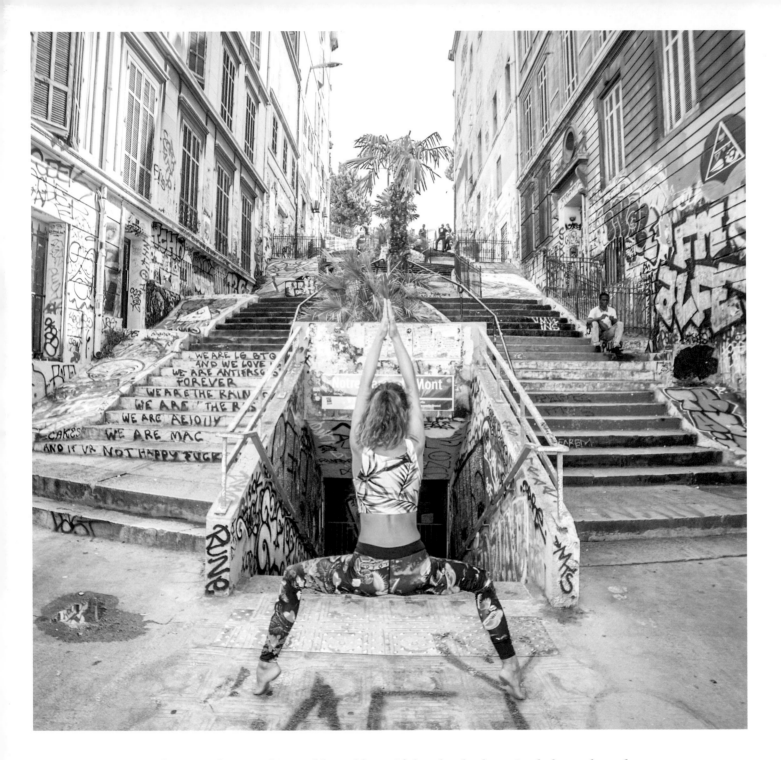

When you do something noble and beautiful and nobody noticed, do not be sad.
For the sun every morning is a beautiful spectacle and yet most of the audience still sleeps J. LENON

MARSEILLE

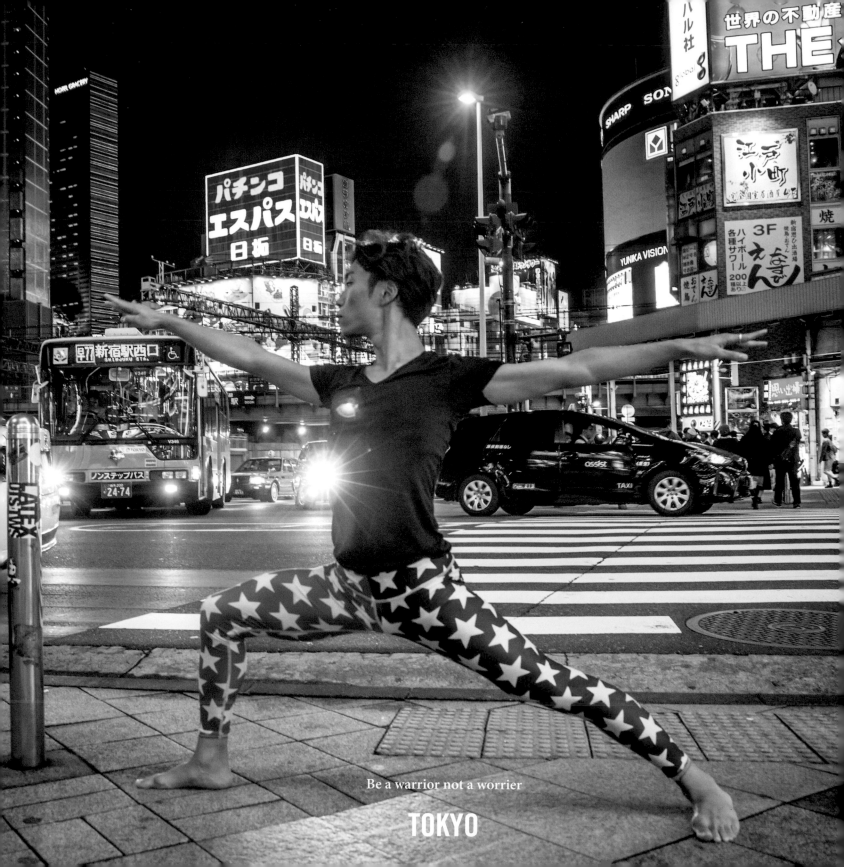

Be a warrior not a worrier

TOKYO

Never regret a day in your life.
Good days give happiness,
bad days give experience,
the worst days give lessons,
and best days give memories

MOSCOW

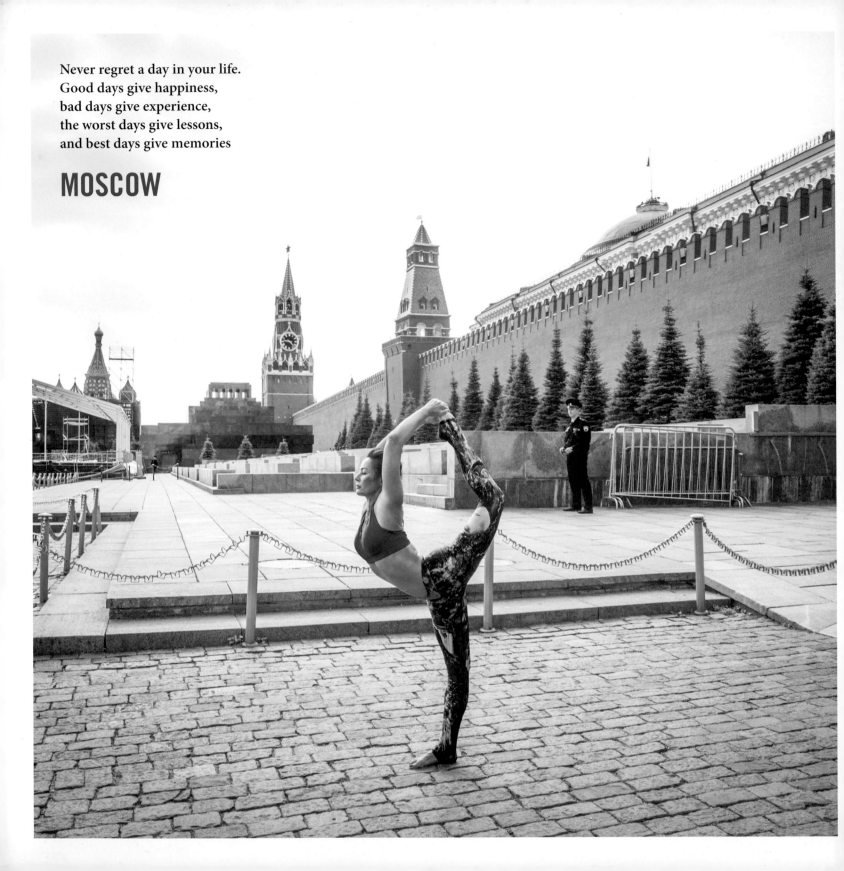

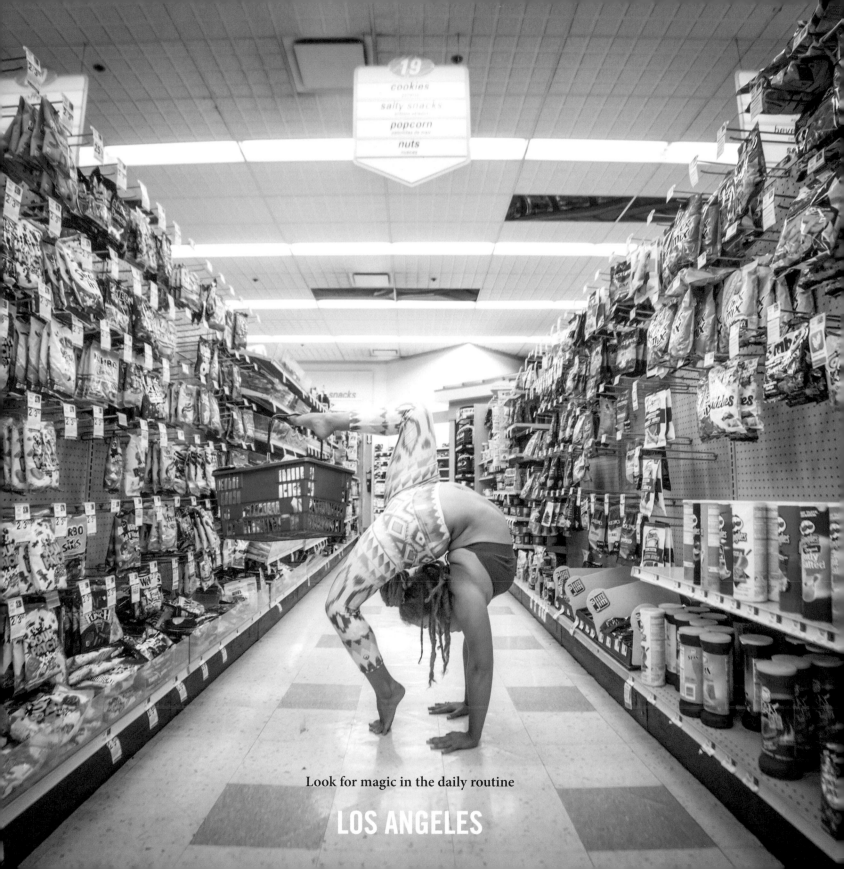

Look for magic in the daily routine

LOS ANGELES

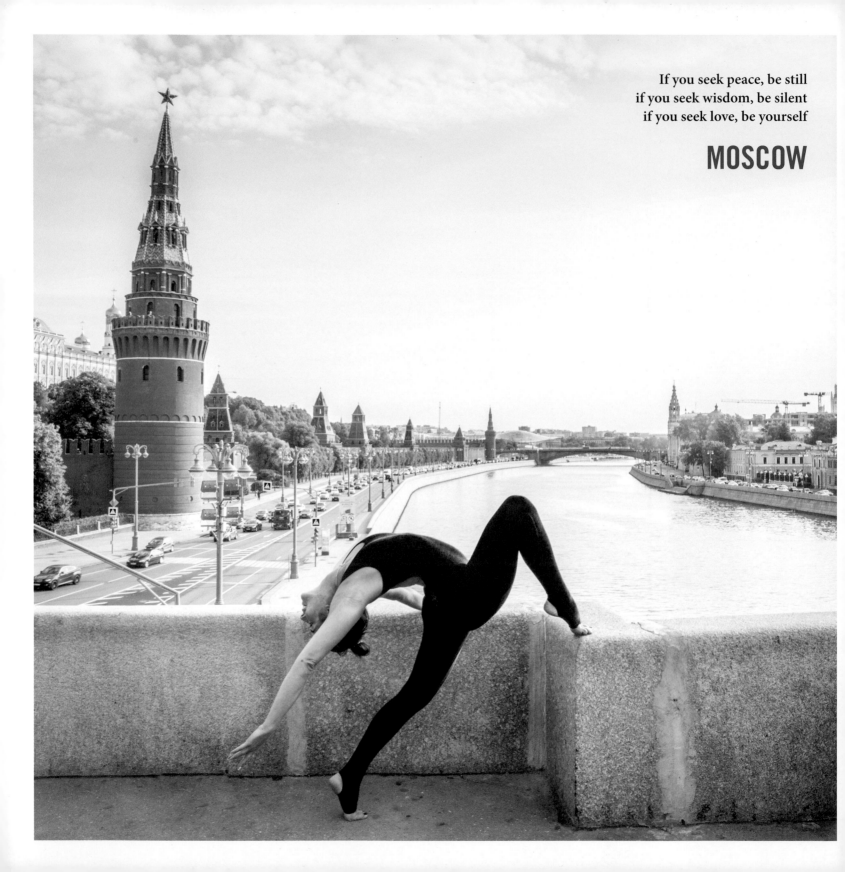

If you seek peace, be still
if you seek wisdom, be silent
if you seek love, be yourself

MOSCOW

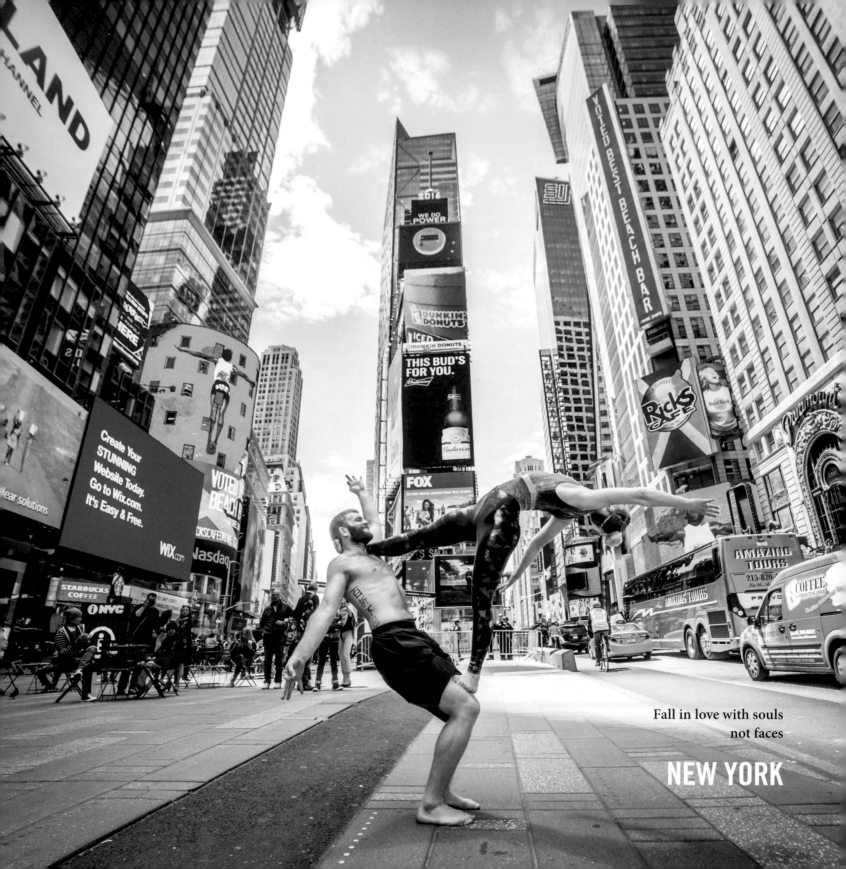

Fall in love with souls
not faces

NEW YORK

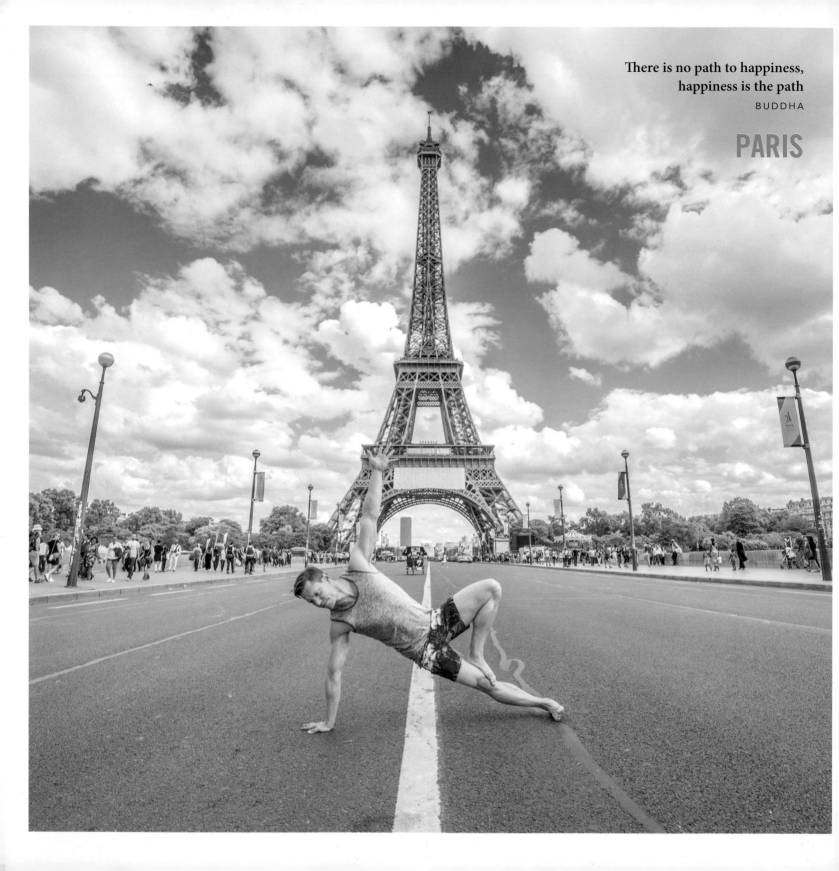

There is no path to happiness,
happiness is the path

BUDDHA

PARIS

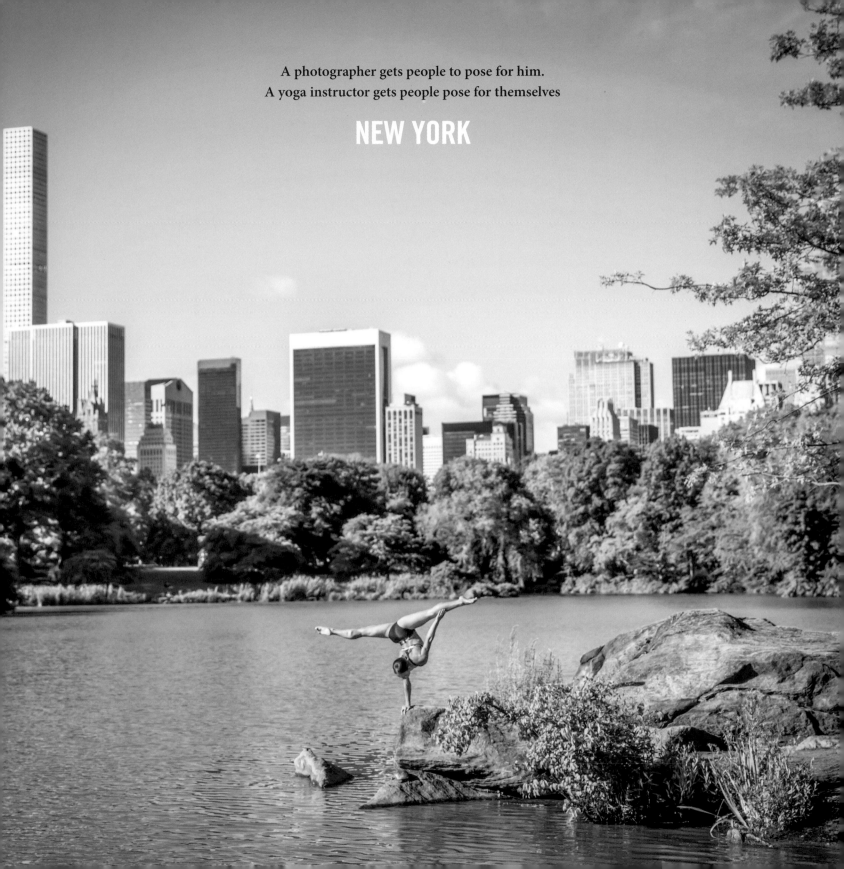

A photographer gets people to pose for him.
A yoga instructor gets people pose for themselves

NEW YORK

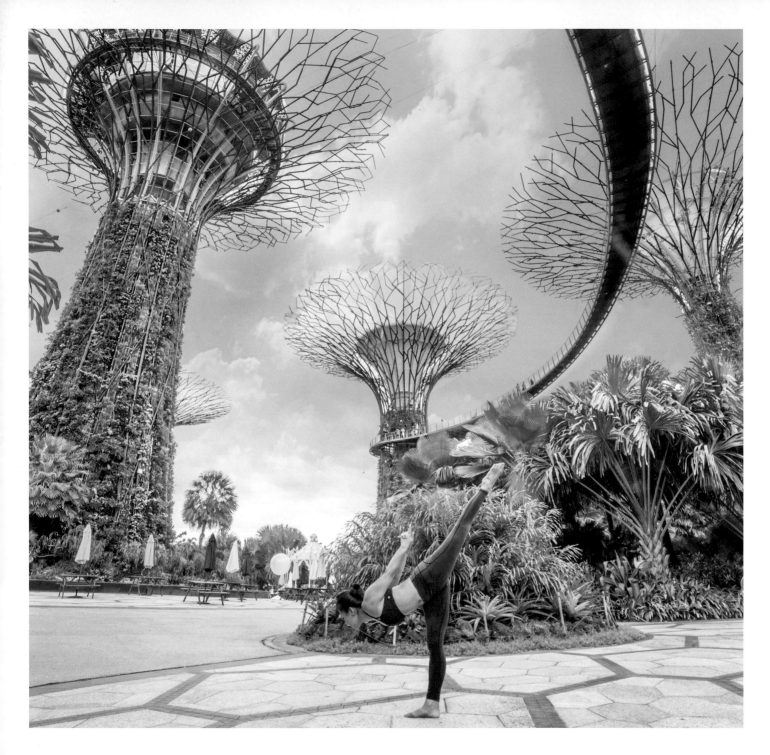

Life does not have to be perfect
to be wonderful

SINGAPORE

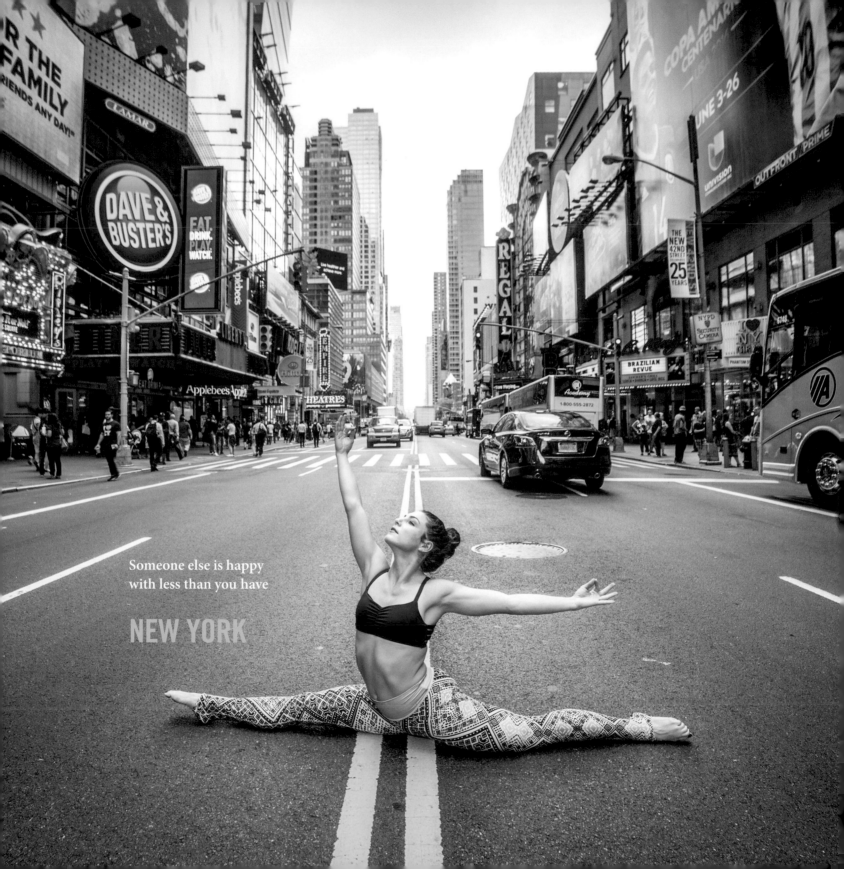

Someone else is happy
with less than you have

NEW YORK

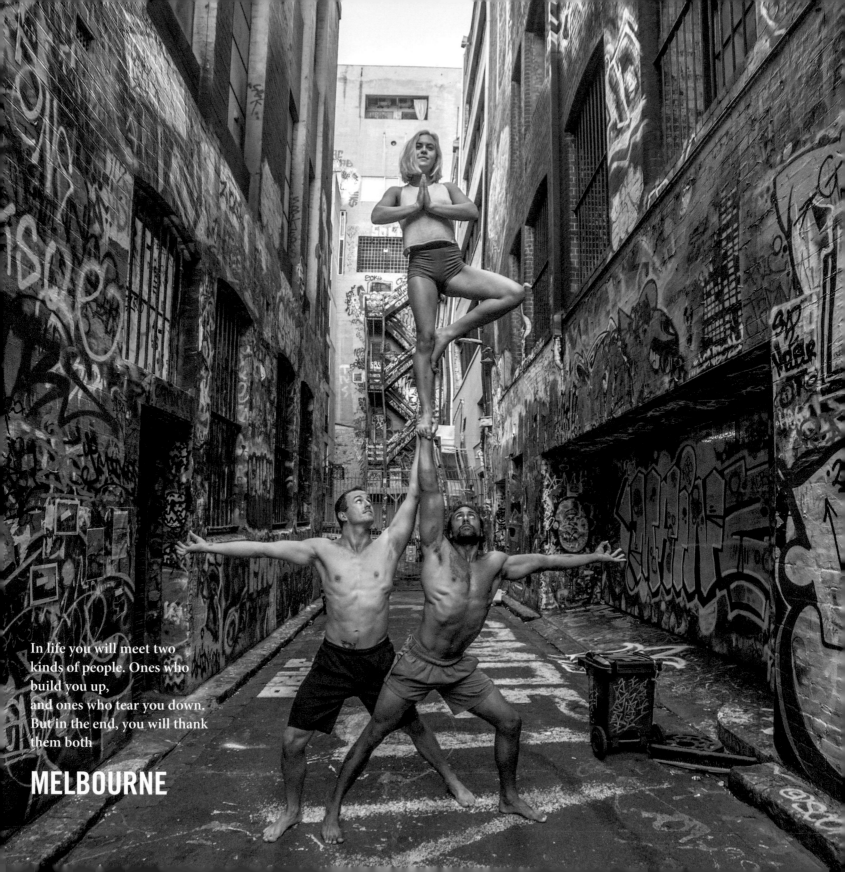

In life you will meet two
kinds of people. Ones who
build you up,
and ones who tear you down.
But in the end, you will thank
them both

MELBOURNE

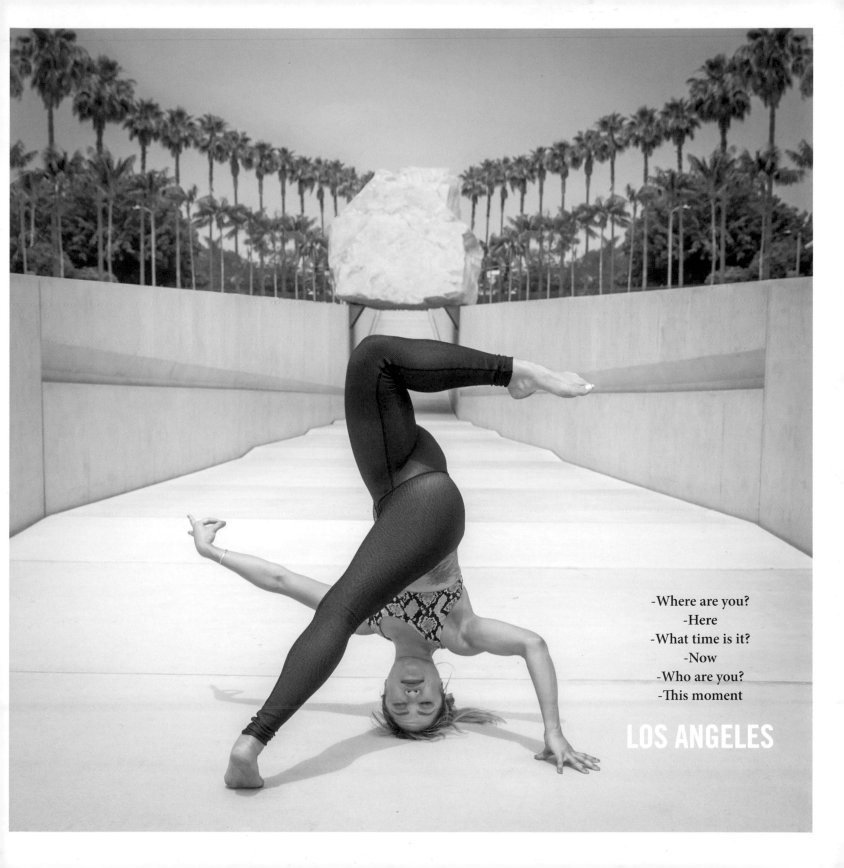

-Where are you?
-Here
-What time is it?
-Now
-Who are you?
-This moment

LOS ANGELES

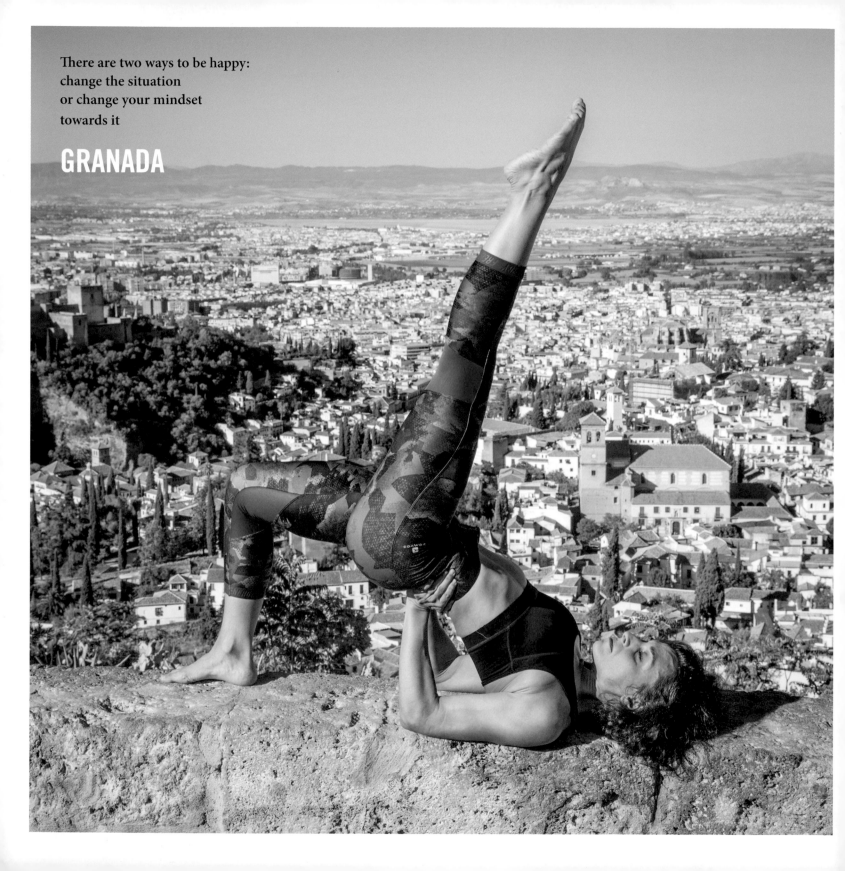

There are two ways to be happy:
change the situation
or change your mindset
towards it

GRANADA

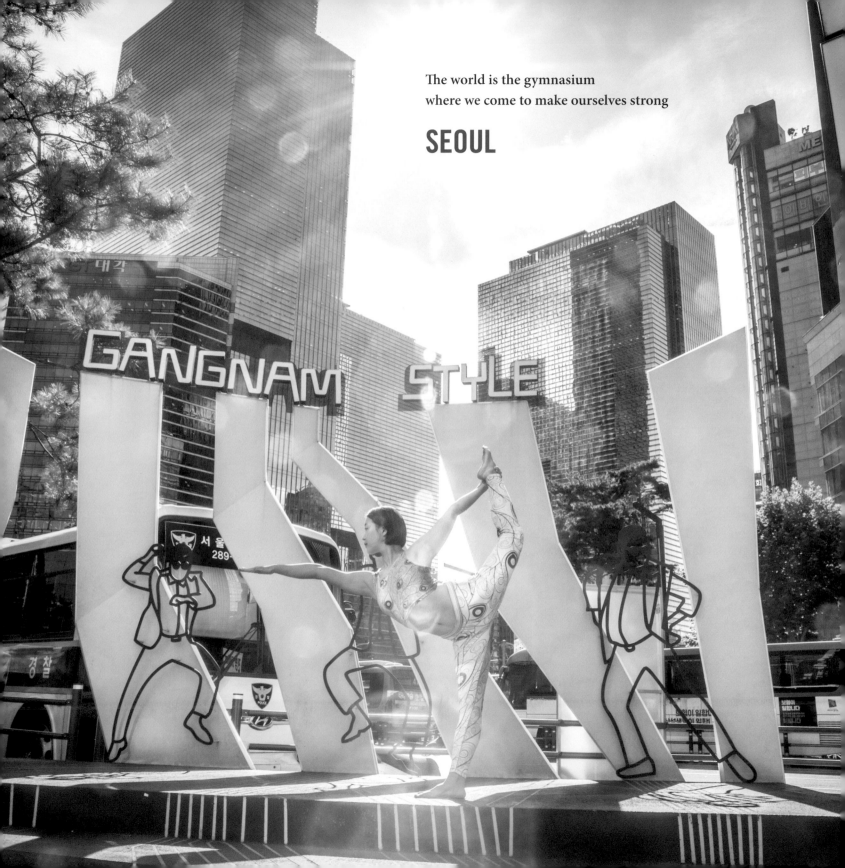

The world is the gymnasium
where we come to make ourselves strong

SEOUL

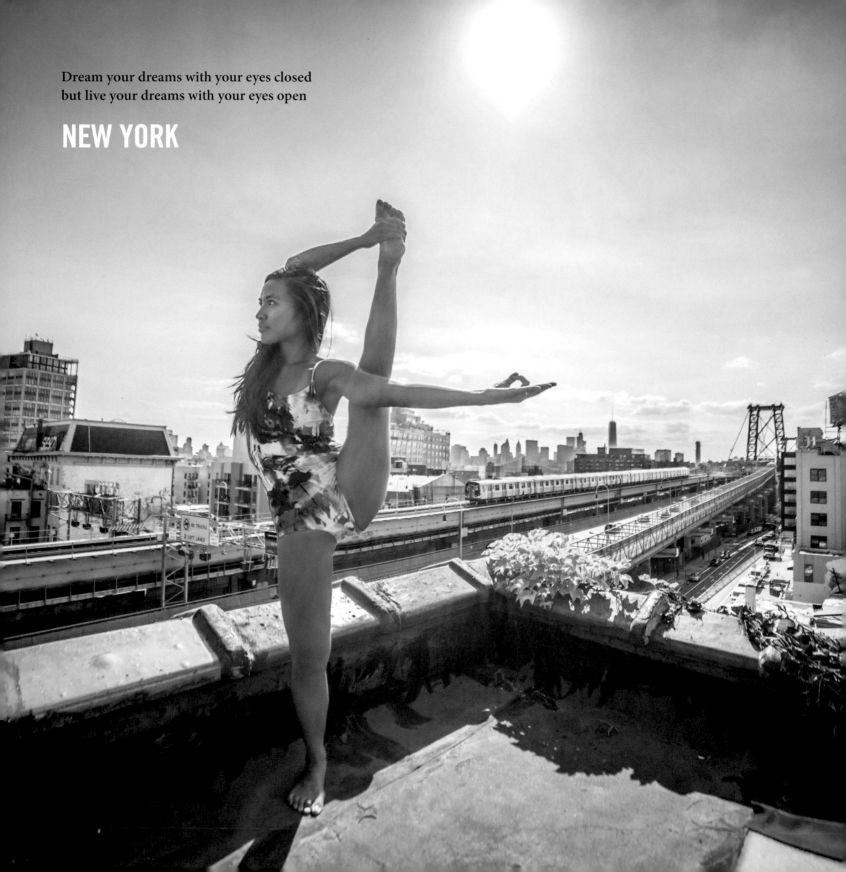

Dream your dreams with your eyes closed
but live your dreams with your eyes open

NEW YORK

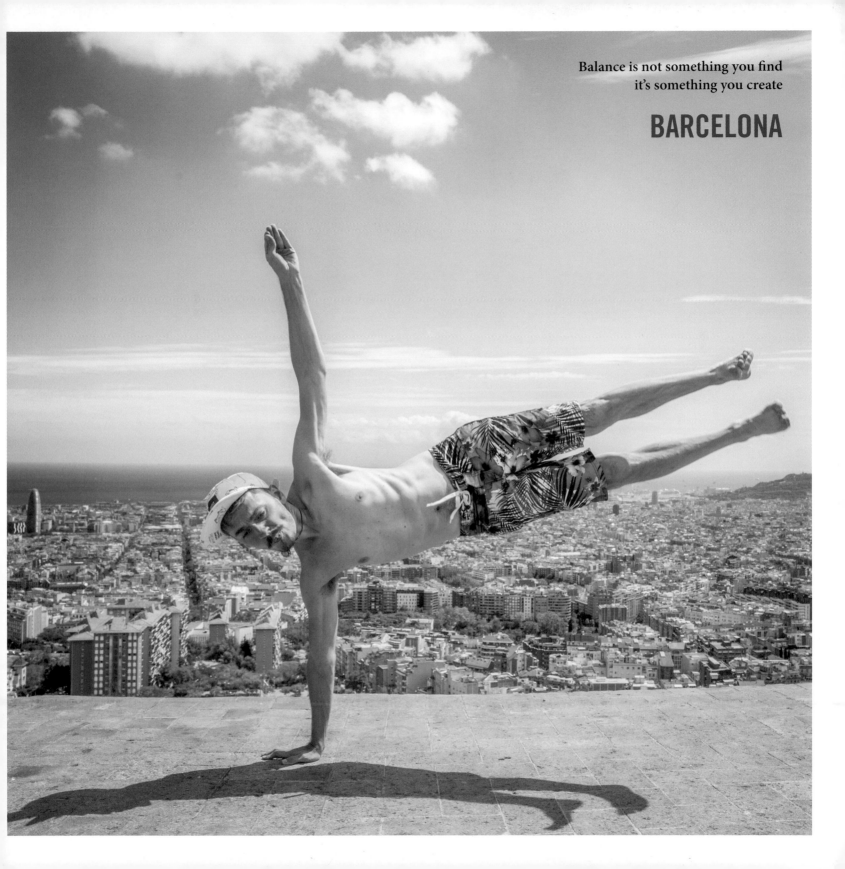

Balance is not something you find
it's something you create

BARCELONA

You will never be able to escape from your heart.
So it's better to listen to what it has to say PAULO COELHO

MOSCOW

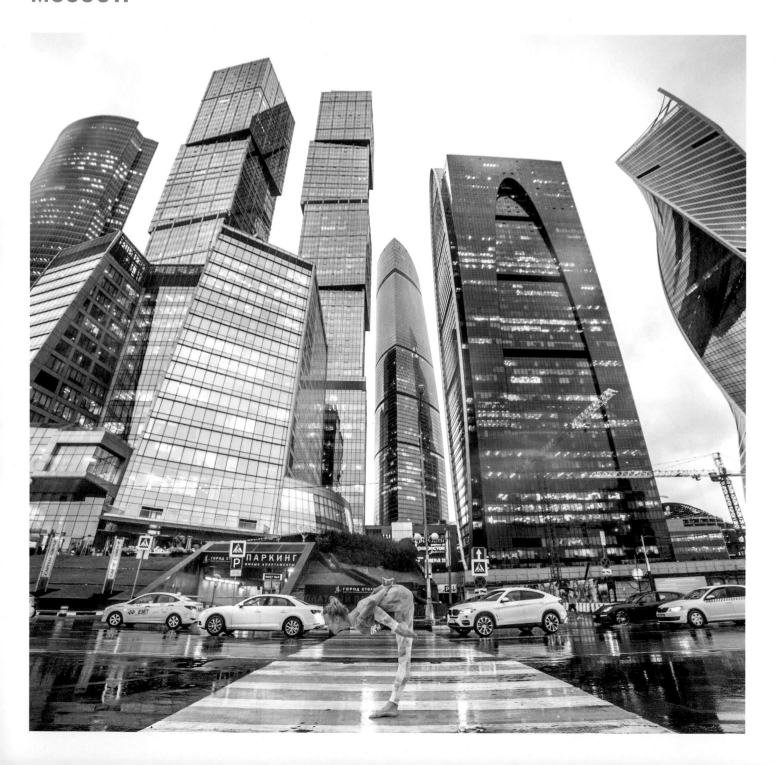

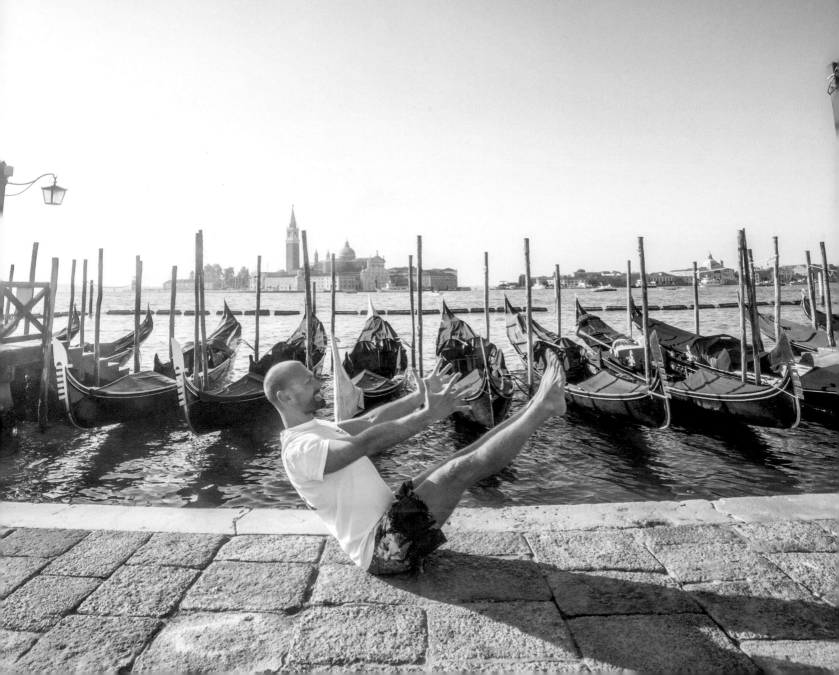

Let your boat of life be light,
packed with only what you need
JEROME K. JEROME

VENICE

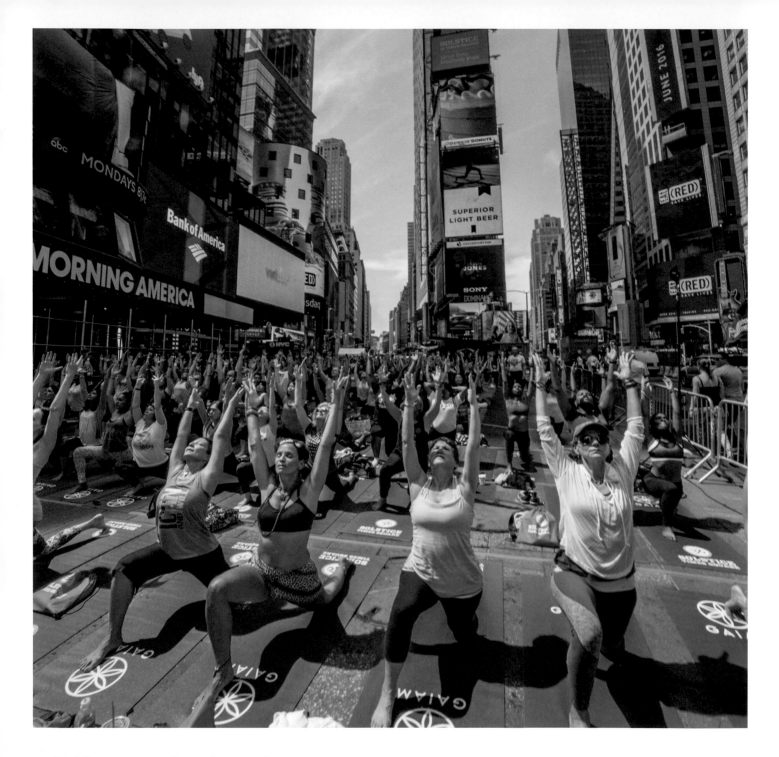

In this life we can not always do great things
but we can do small things with great love

NEW YORK

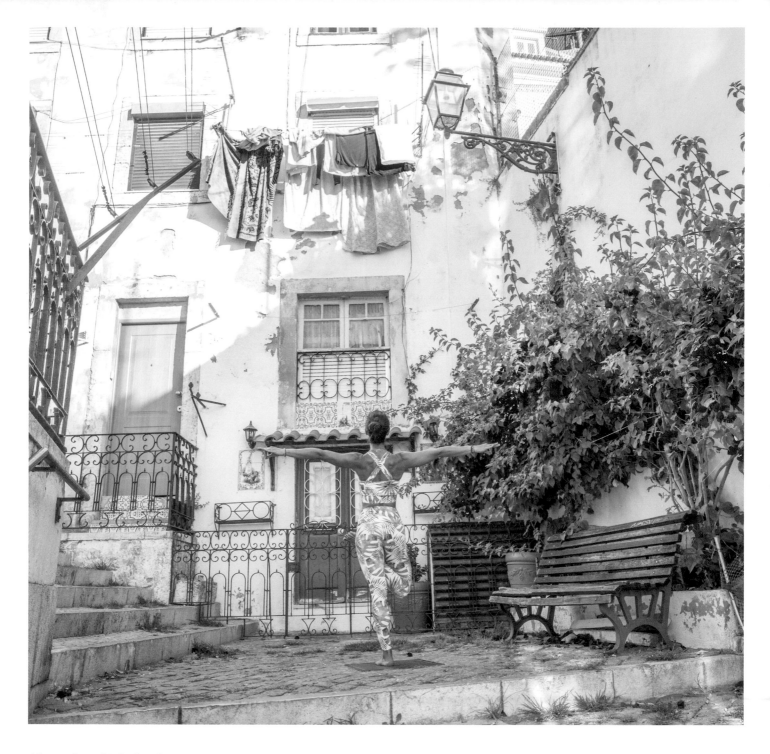

**Always be a little kinder
than necessary** J. M. BARRIE

LISBON

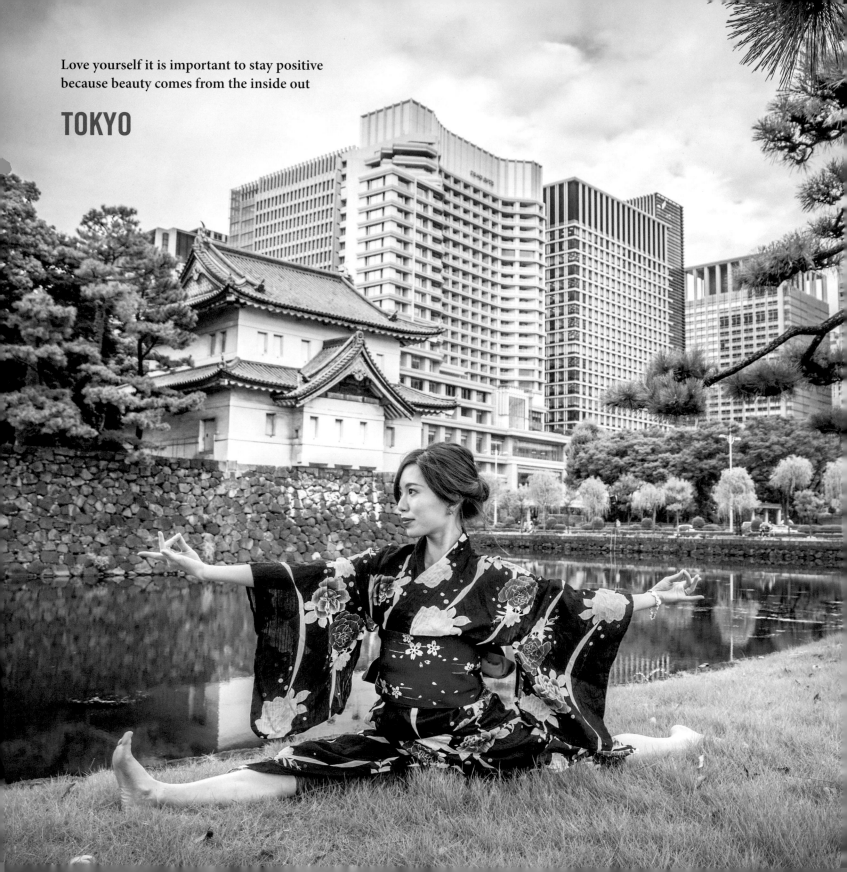

Love yourself it is important to stay positive
because beauty comes from the inside out

TOKYO

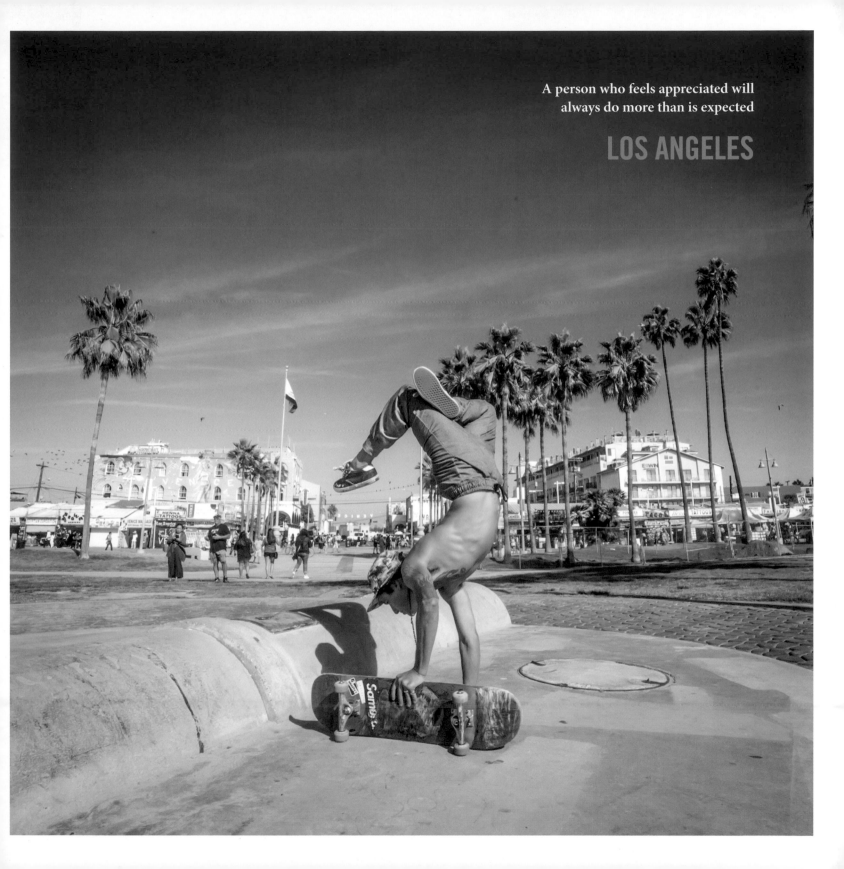

A person who feels appreciated will
always do more than is expected

LOS ANGELES

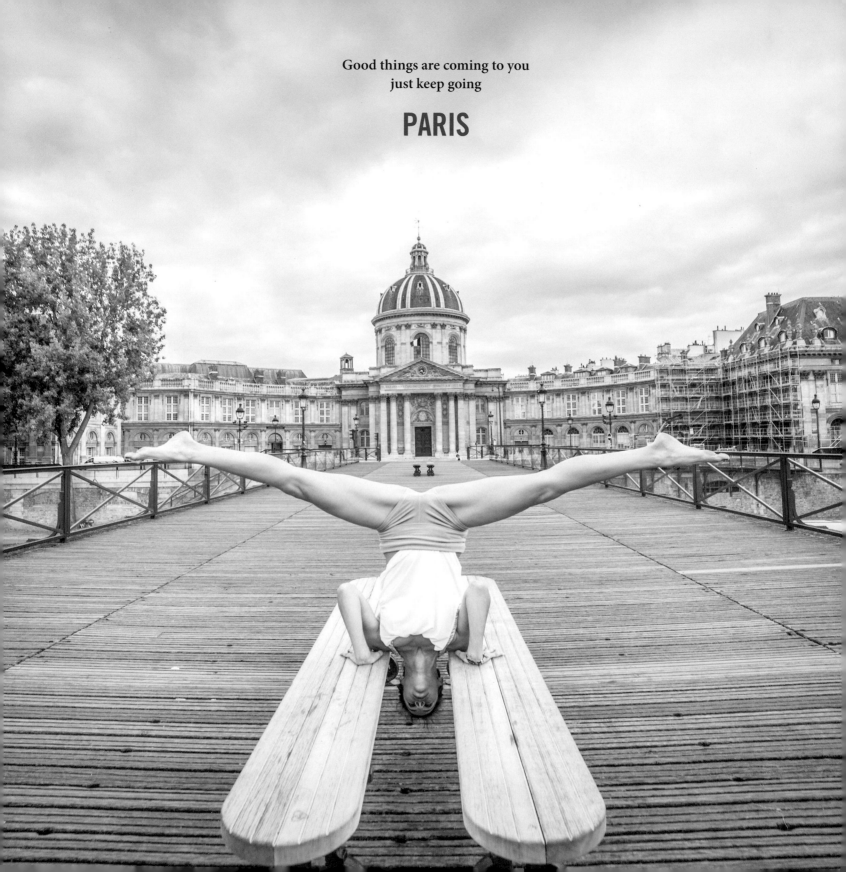

Good things are coming to you
just keep going

PARIS

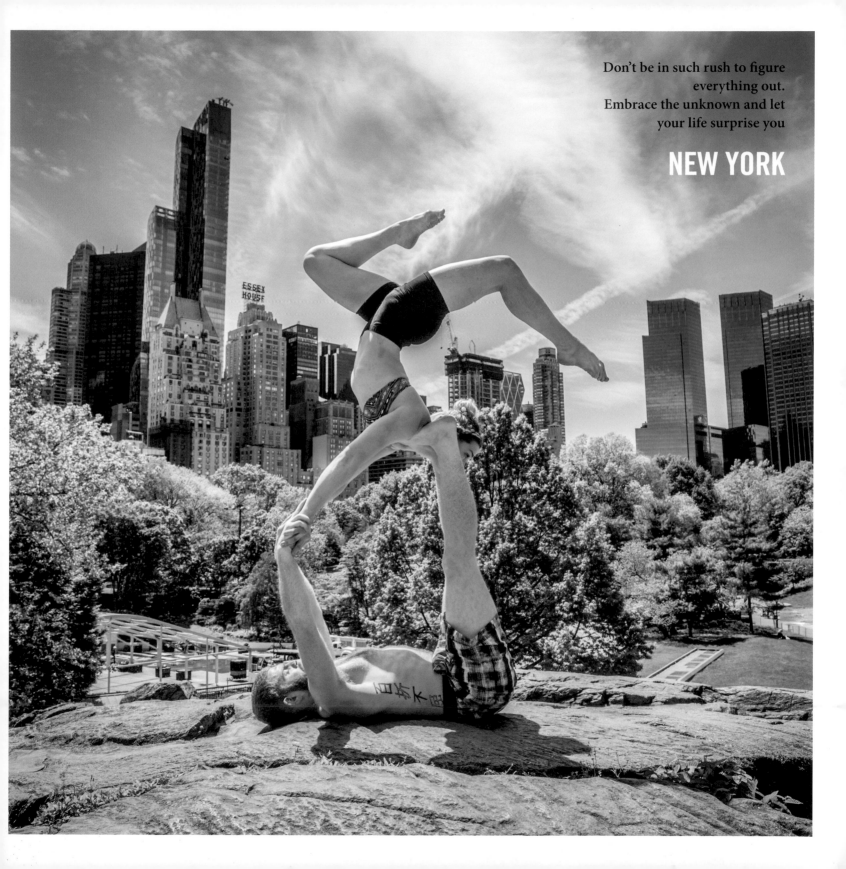

Don't be in such rush to figure
everything out.
Embrace the unknown and let
your life surprise you

NEW YORK

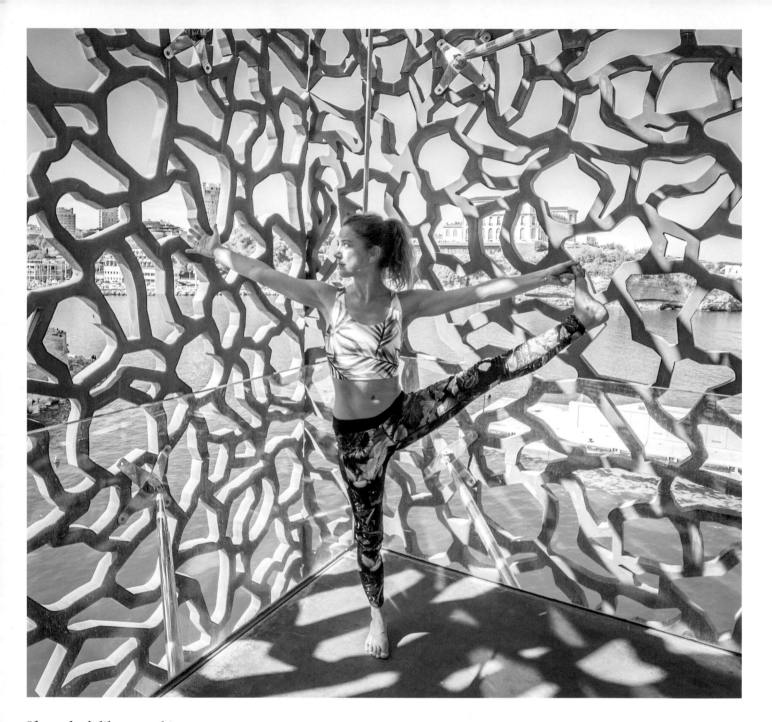

If you don't like something
change it.
If you can't change it
change your attitude MAYA ANGELOU

MARSEILLE

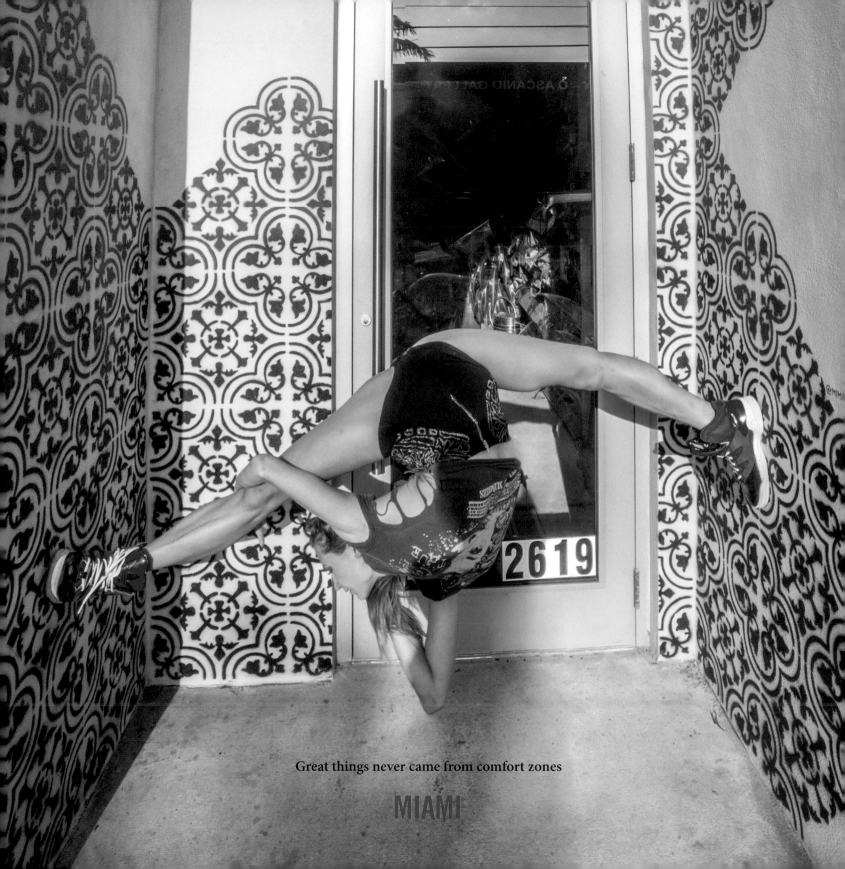

Great things never came from comfort zones

MIAMI

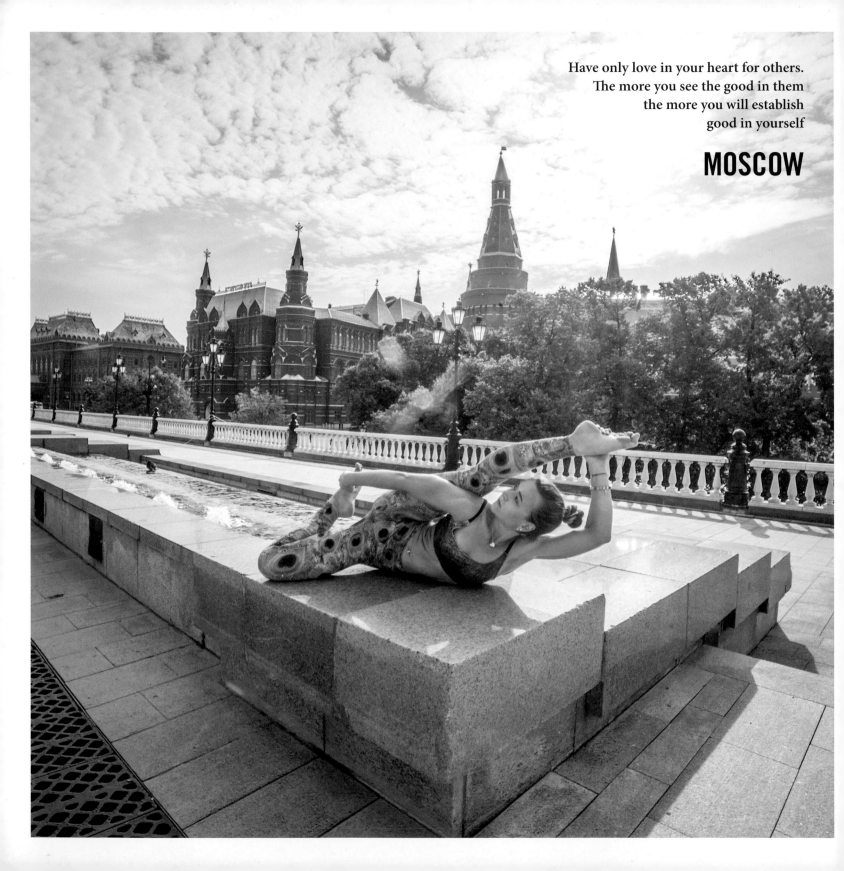

Have only love in your heart for others.
The more you see the good in them
the more you will establish
good in yourself

MOSCOW

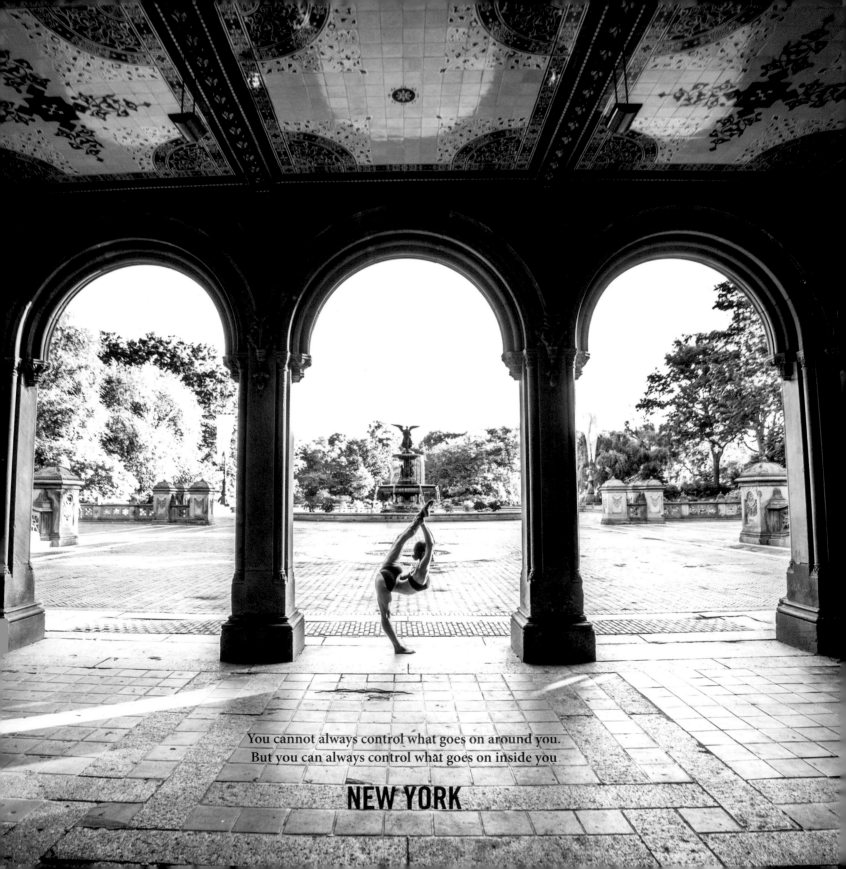

You cannot always control what goes on around you.
But you can always control what goes on inside you

NEW YORK

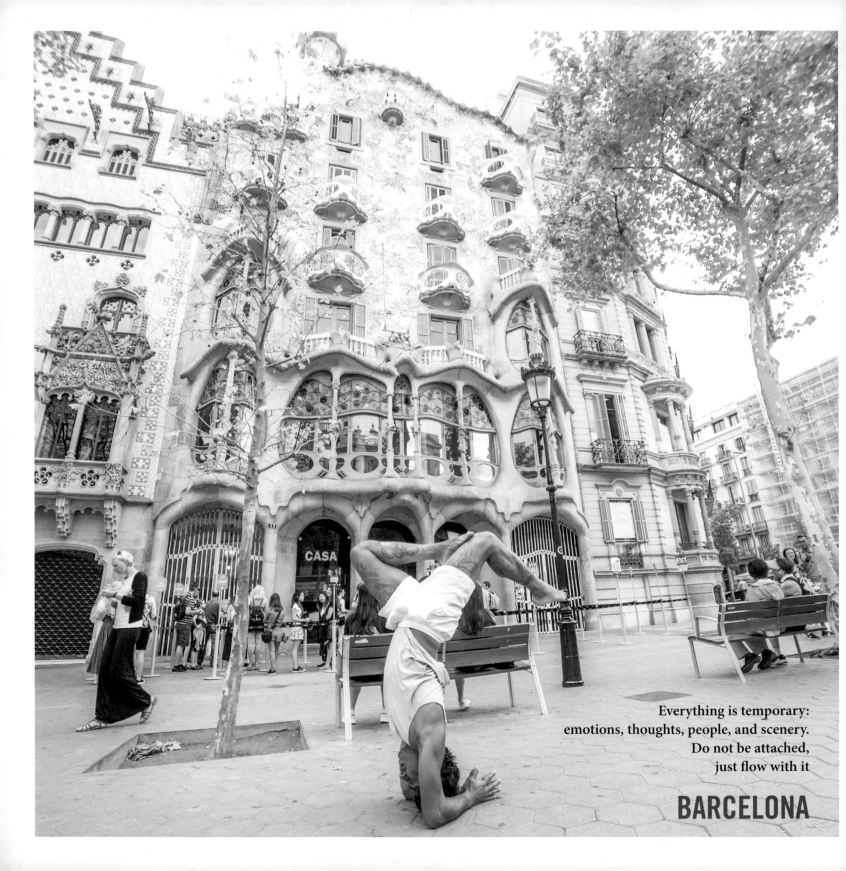

Everything is temporary:
emotions, thoughts, people, and scenery.
Do not be attached,
just flow with it

BARCELONA

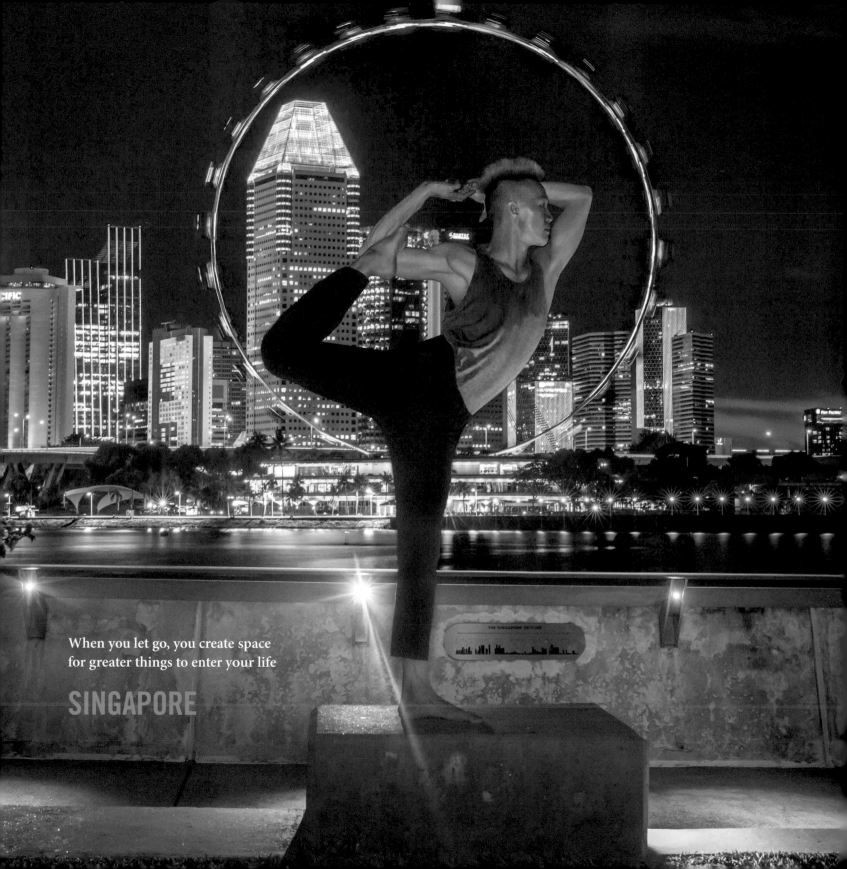

When you let go, you create space
for greater things to enter your life

SINGAPORE

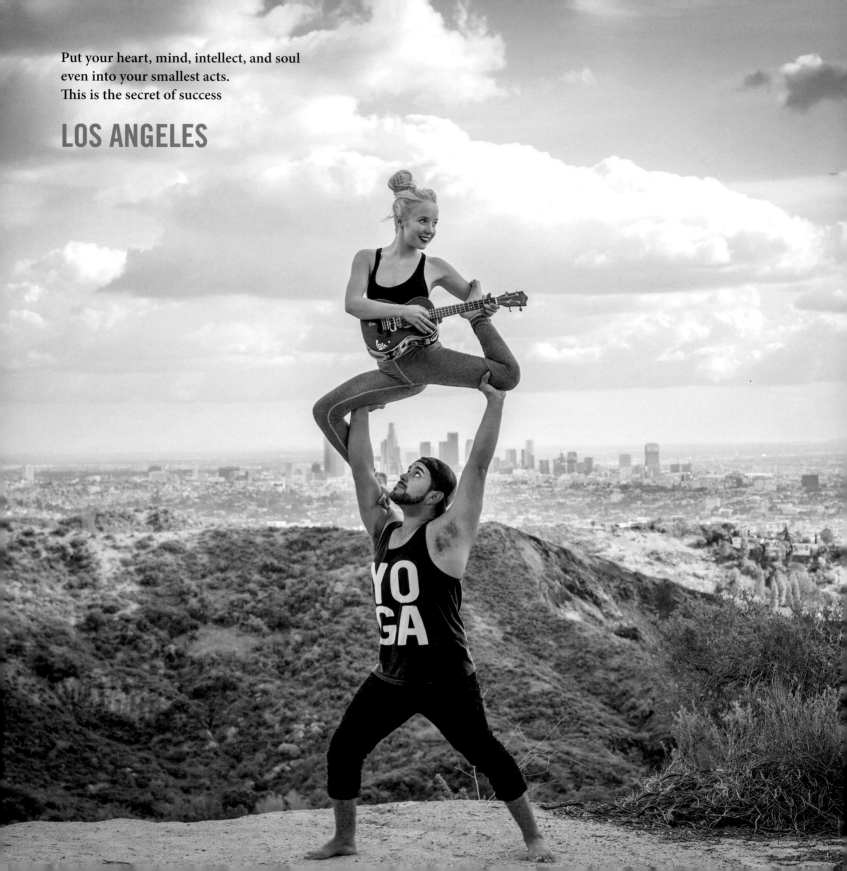

Put your heart, mind, intellect, and soul
even into your smallest acts.
This is the secret of success

LOS ANGELES

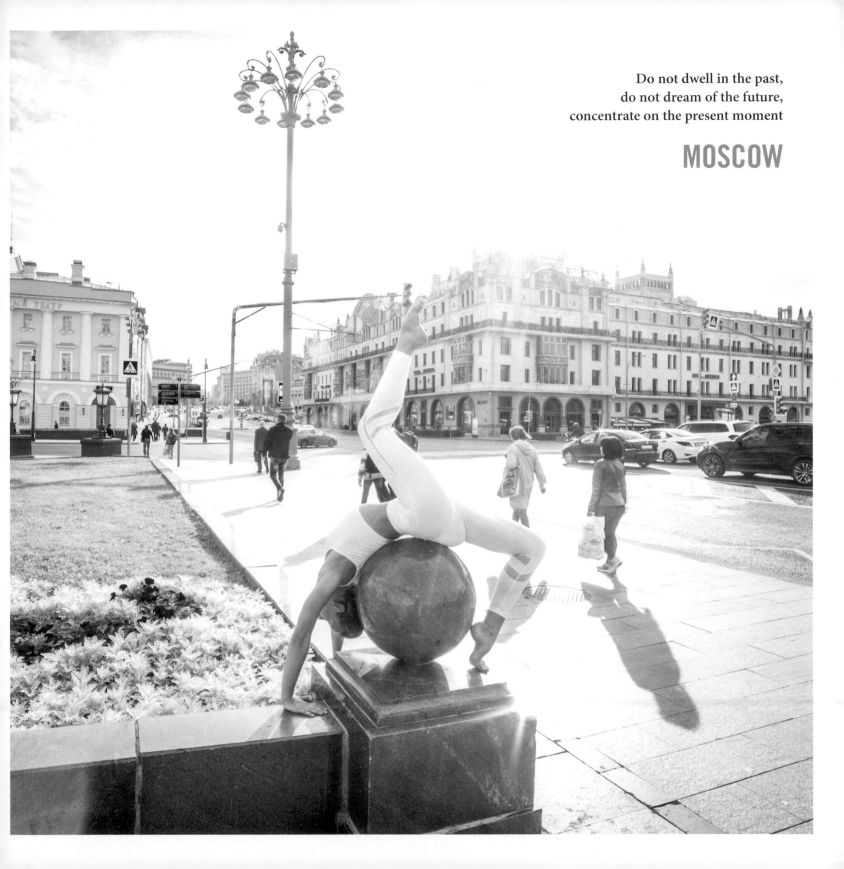

Do not dwell in the past,
do not dream of the future,
concentrate on the present moment

MOSCOW

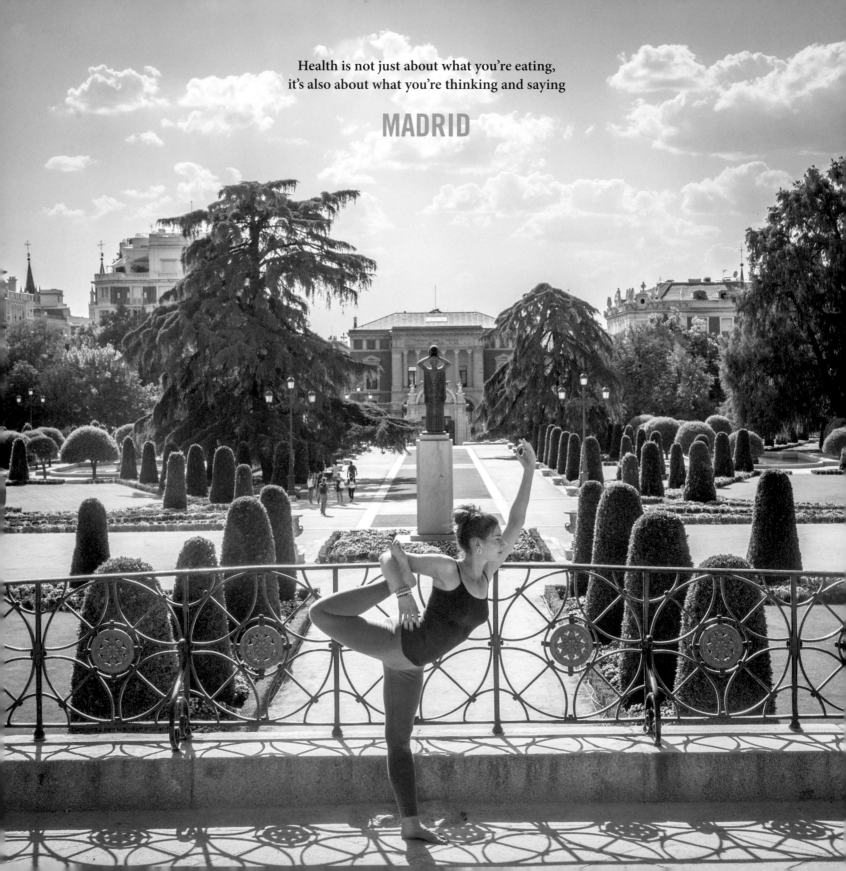

Health is not just about what you're eating,
it's also about what you're thinking and saying

MADRID

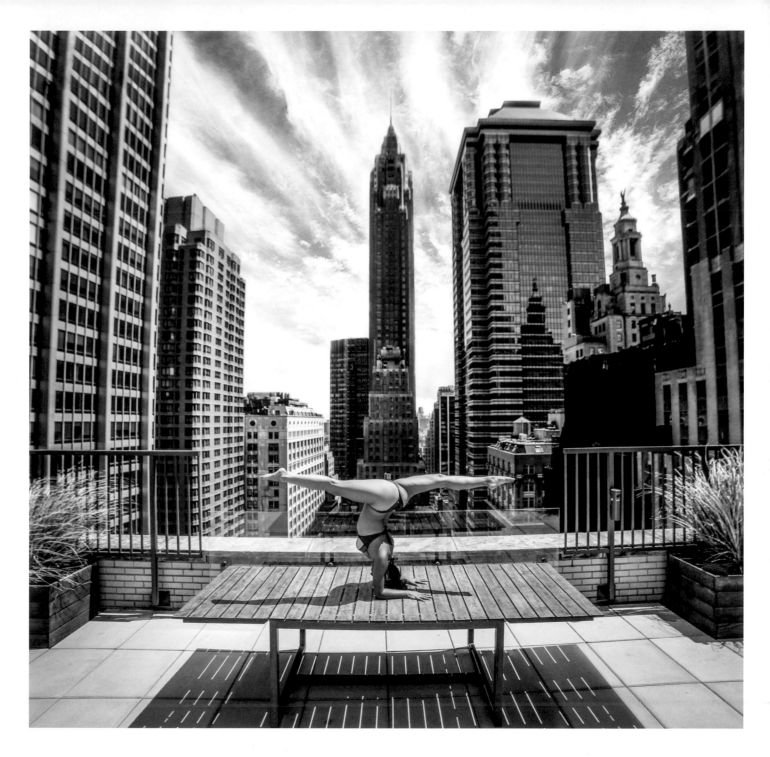

You were born an original.
Don't die a copy

NEW YORK

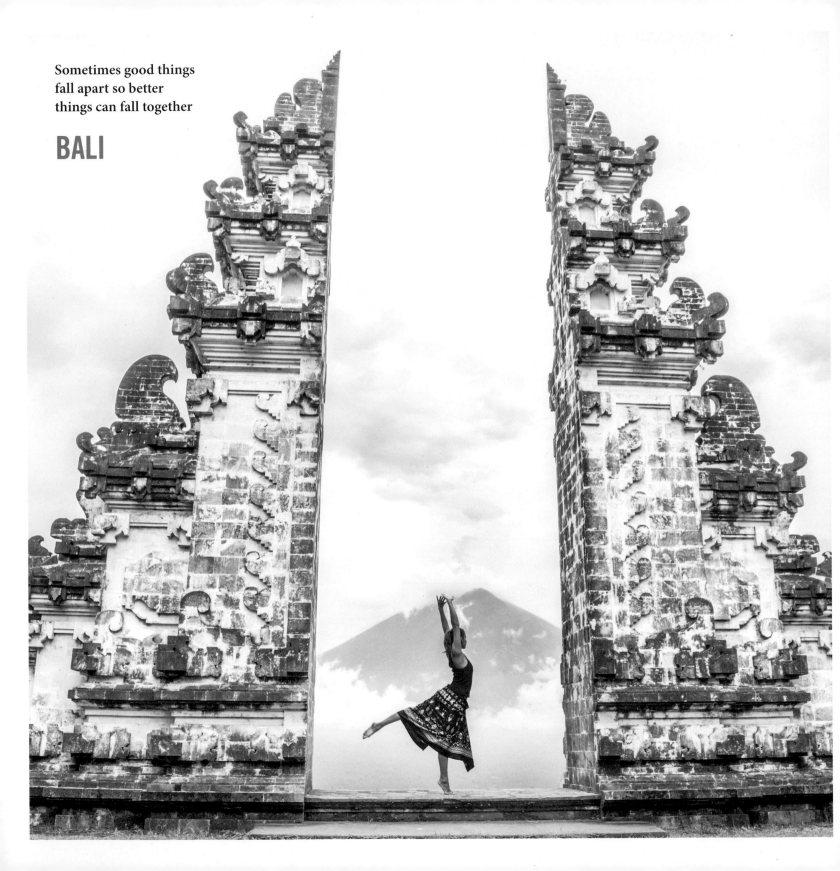

Sometimes good things
fall apart so better
things can fall together

BALI

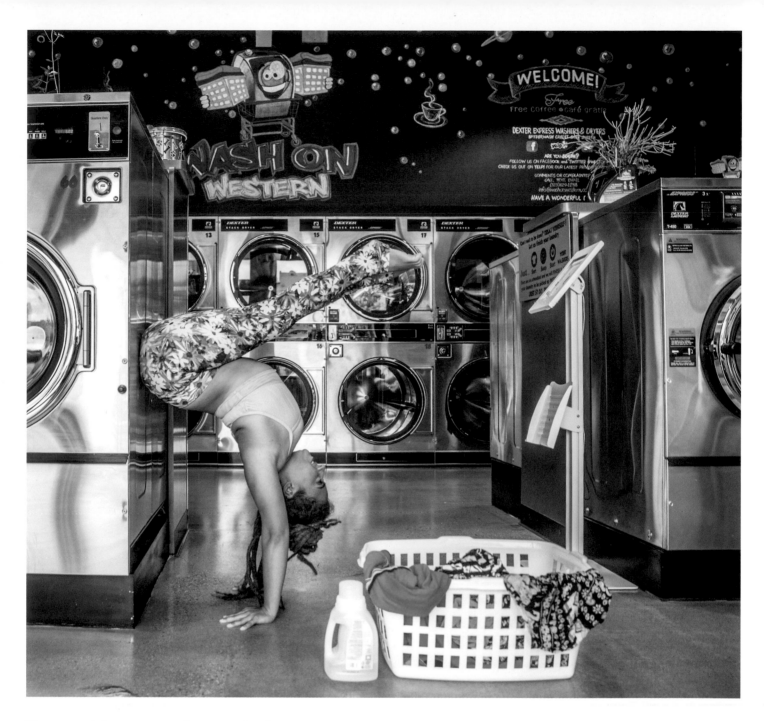

You cannot do yoga, yoga is your natural state.
What you can do are yoga exercises,
which may reveal to you
where you are resisting your natural state

LOS ANGELES

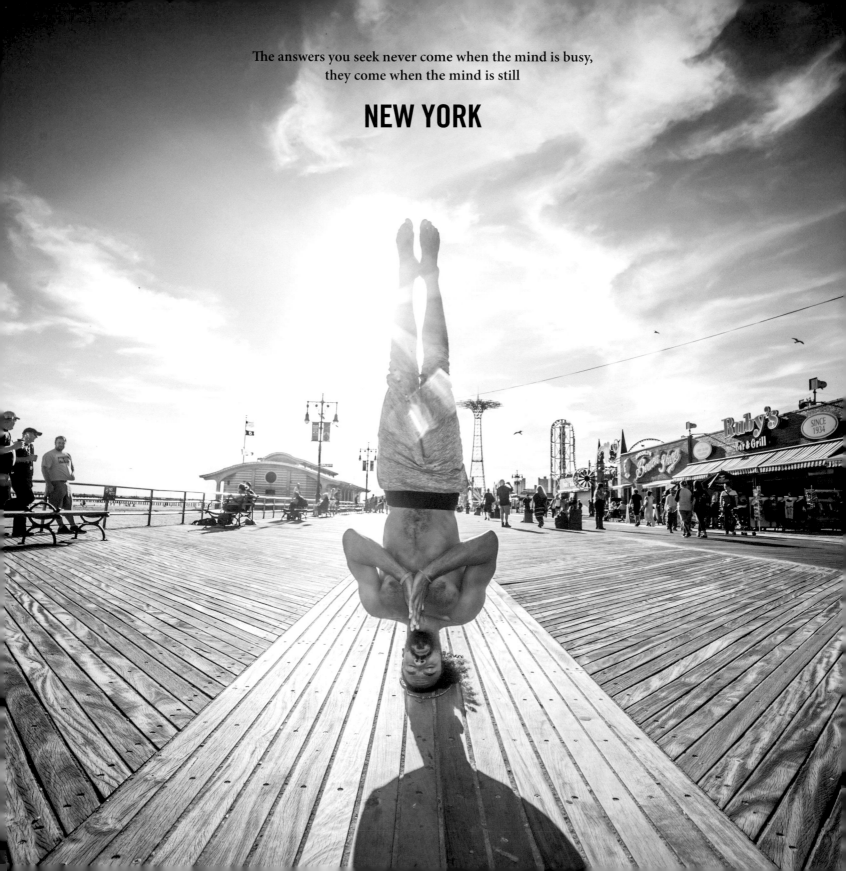

The answers you seek never come when the mind is busy,
they come when the mind is still

NEW YORK

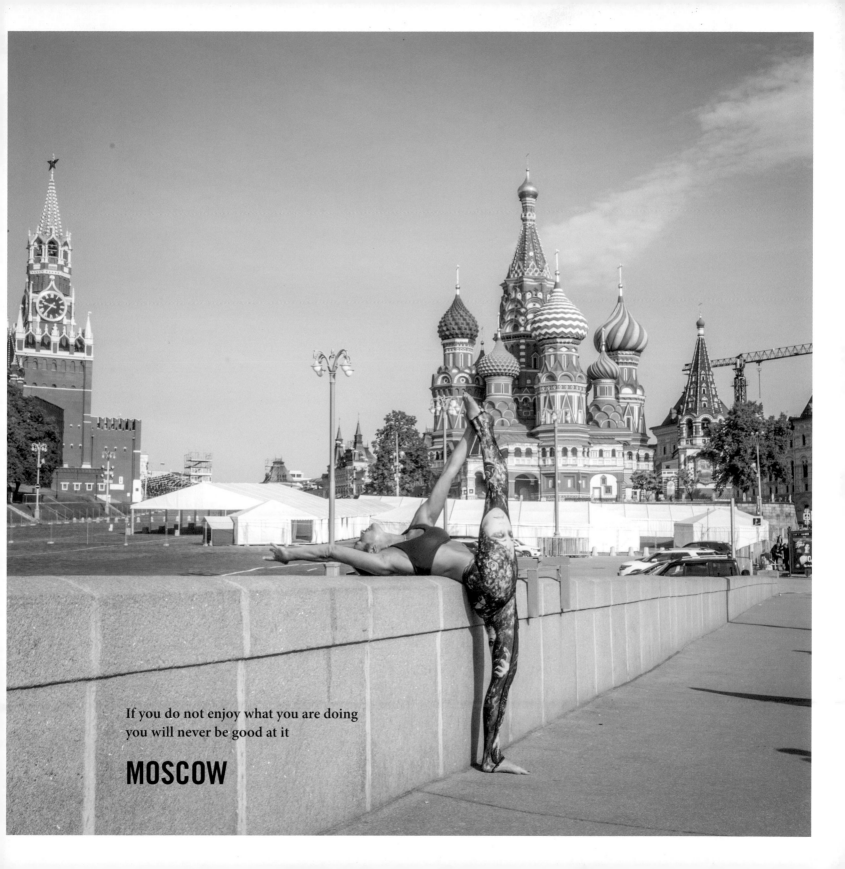

If you do not enjoy what you are doing
you will never be good at it

MOSCOW

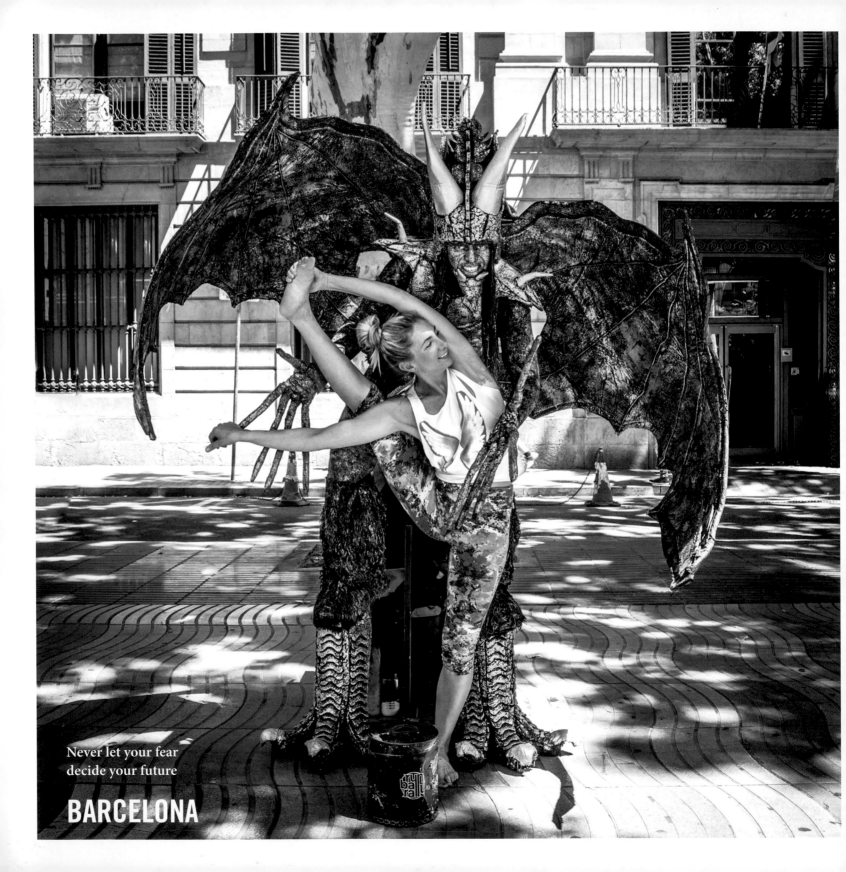

Never let your fear
decide your future

BARCELONA

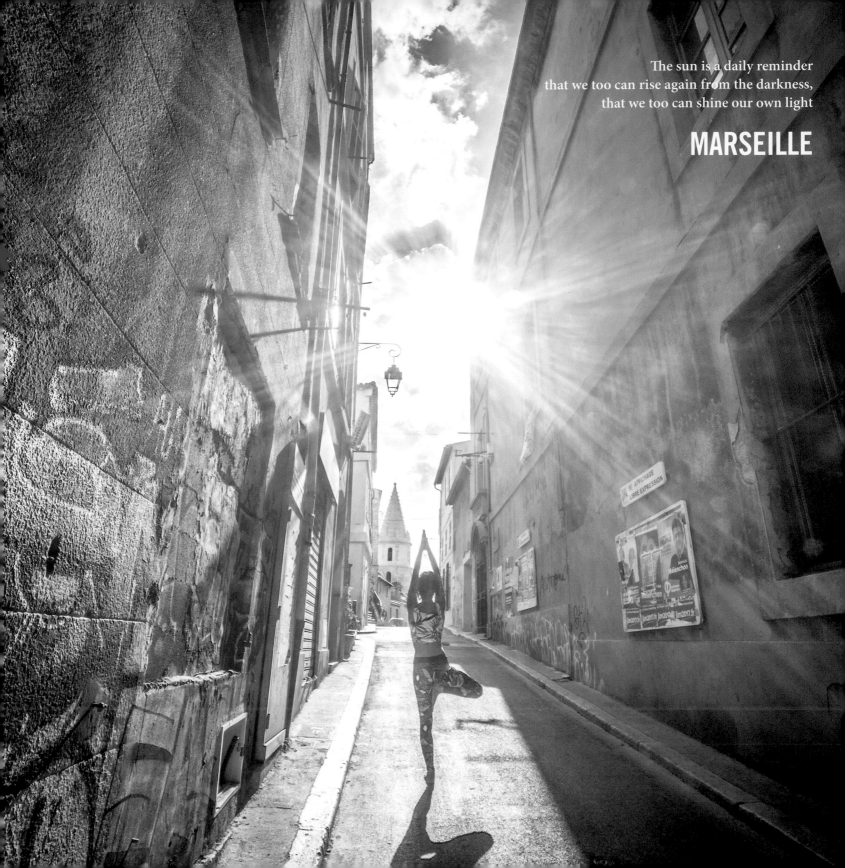

The sun is a daily reminder
that we too can rise again from the darkness,
that we too can shine our own light

MARSEILLE

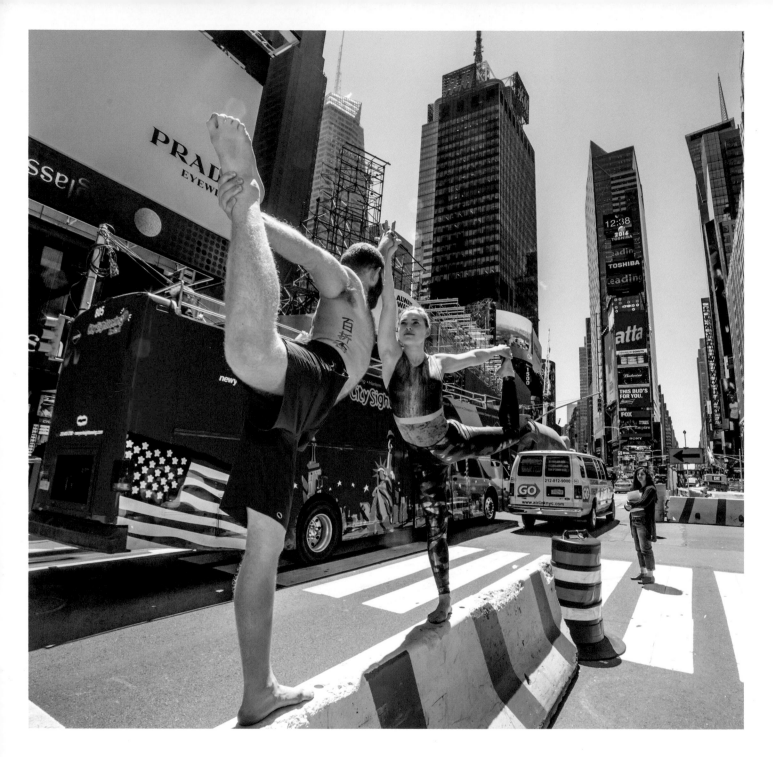

Kindness is not an act,
it's a lifestyle

NEW YORK

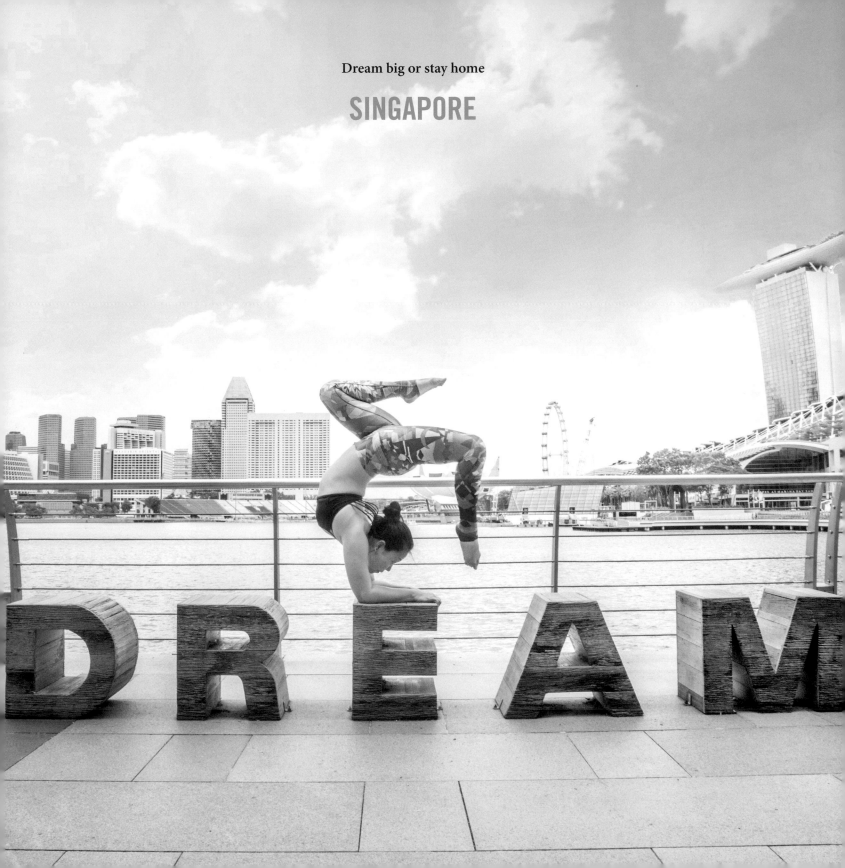

Dream big or stay home

SINGAPORE

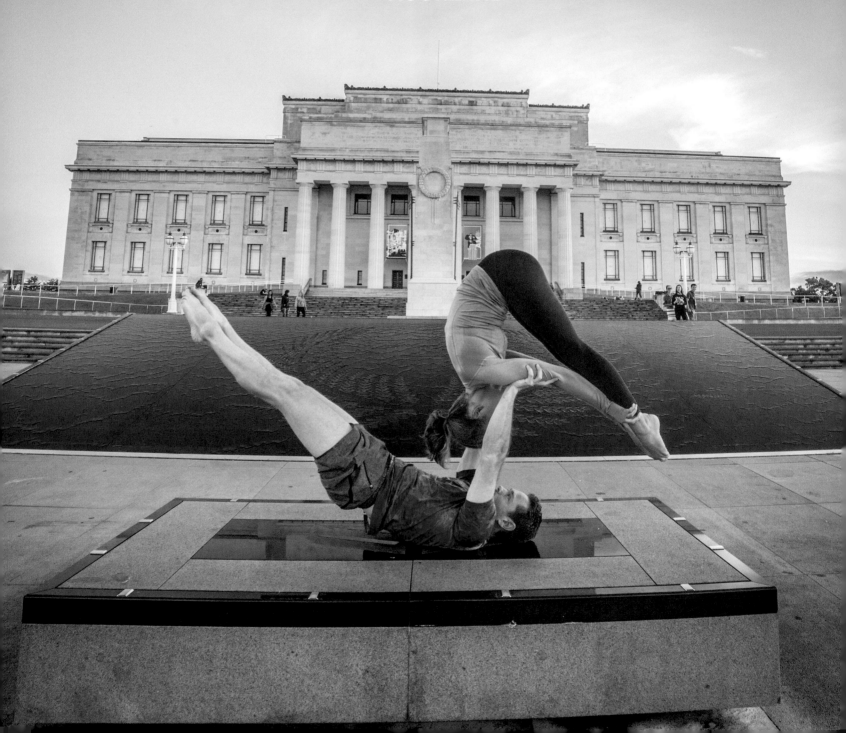

You attract what you are, not what you want.
If you want great then be great

AUCKLAND

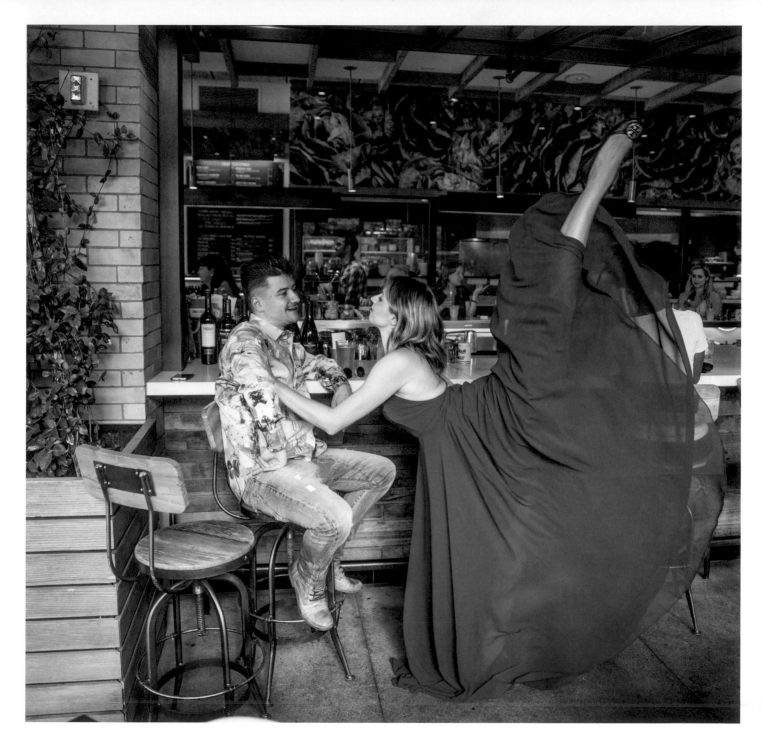

Even after you have rolled up your mat
yoga continues

LOS ANGELES

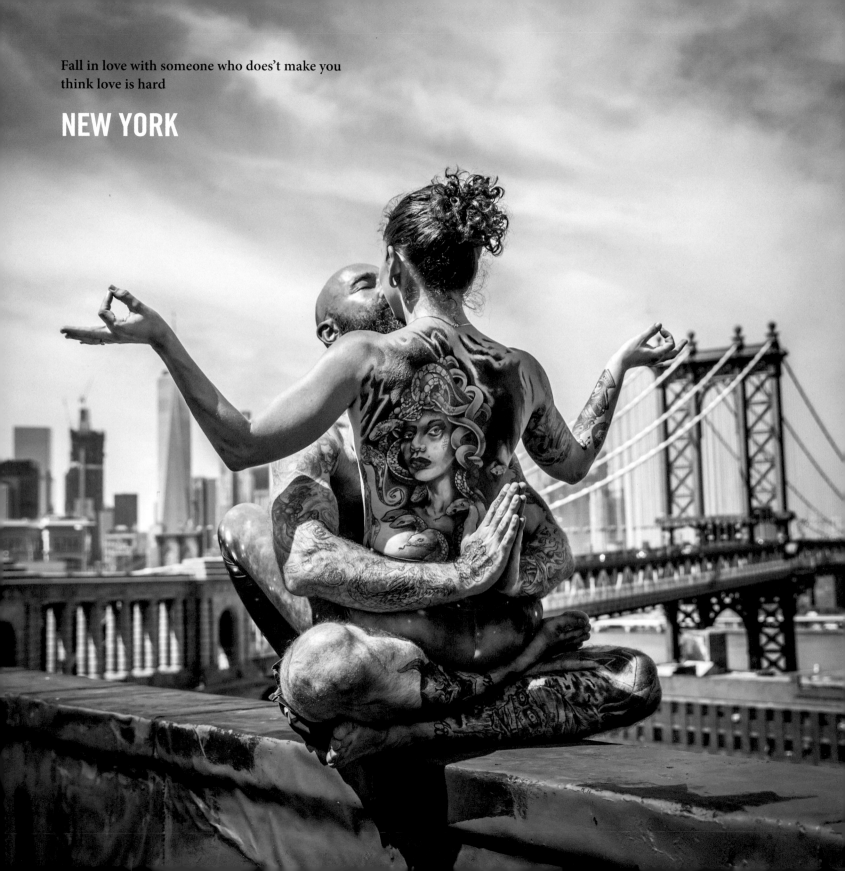

Fall in love with someone who does't make you
think love is hard

NEW YORK

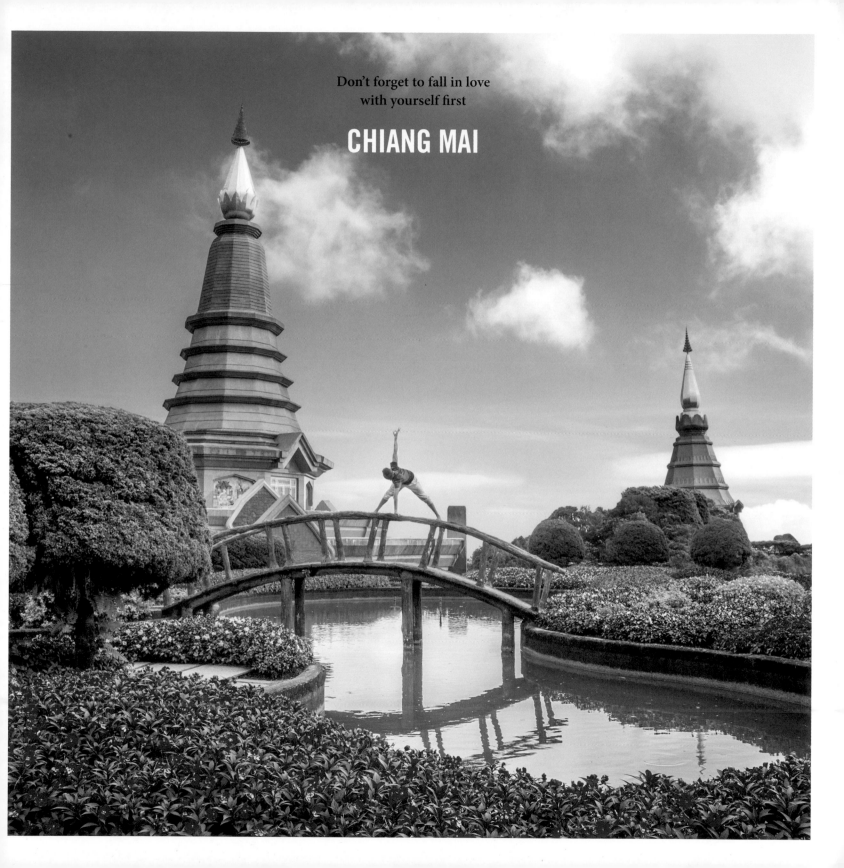

Don't forget to fall in love
with yourself first

CHIANG MAI

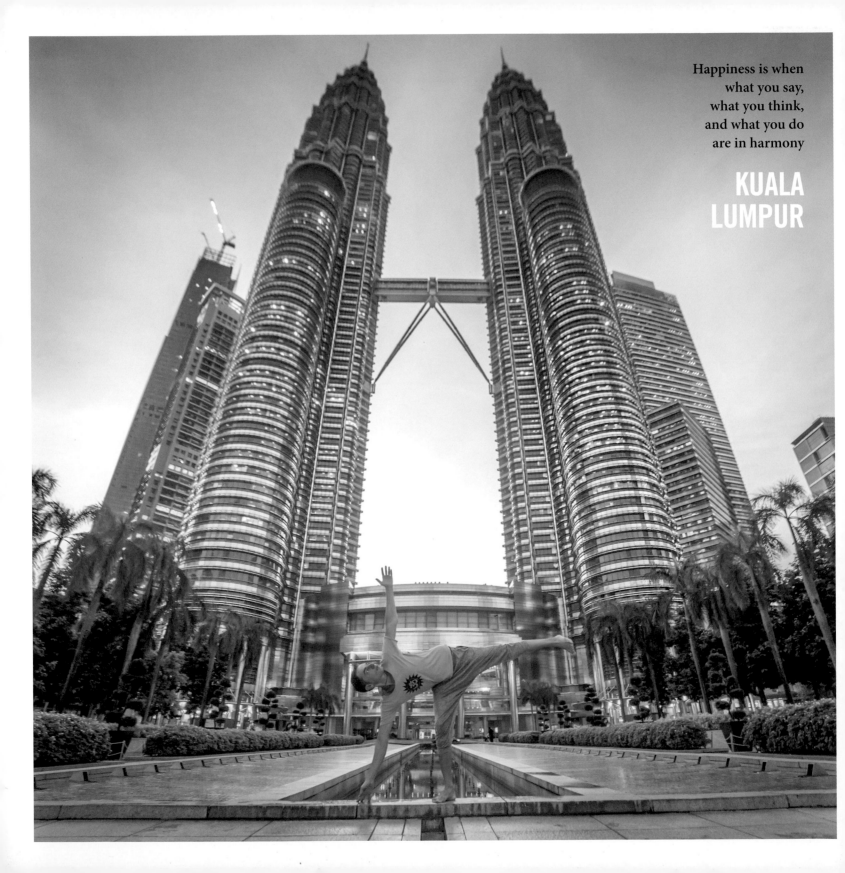

Happiness is when
what you say,
what you think,
and what you do
are in harmony

**KUALA
LUMPUR**

Someday we will find what we
are looking for,
or maybe we won't.
Maybe we will find something
much greater than that

MOSCOW

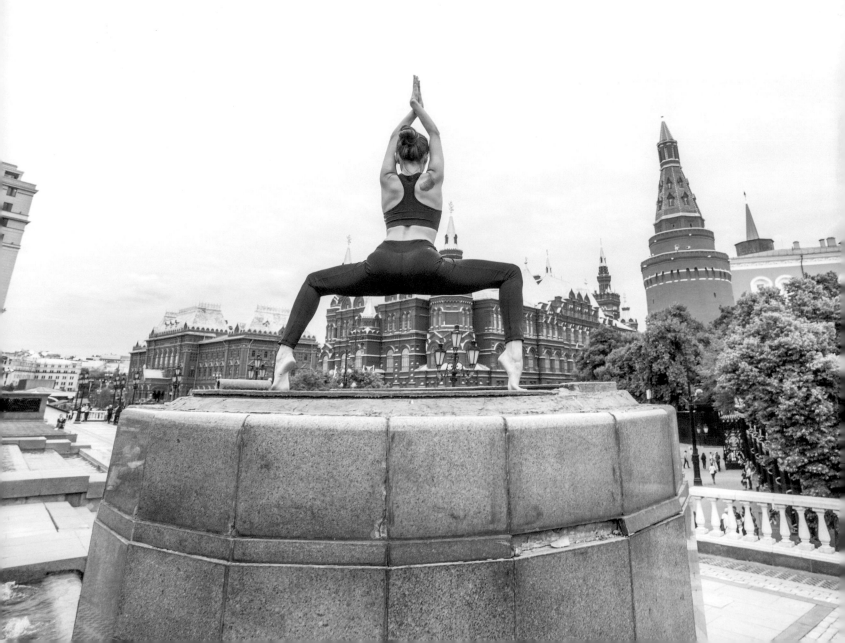

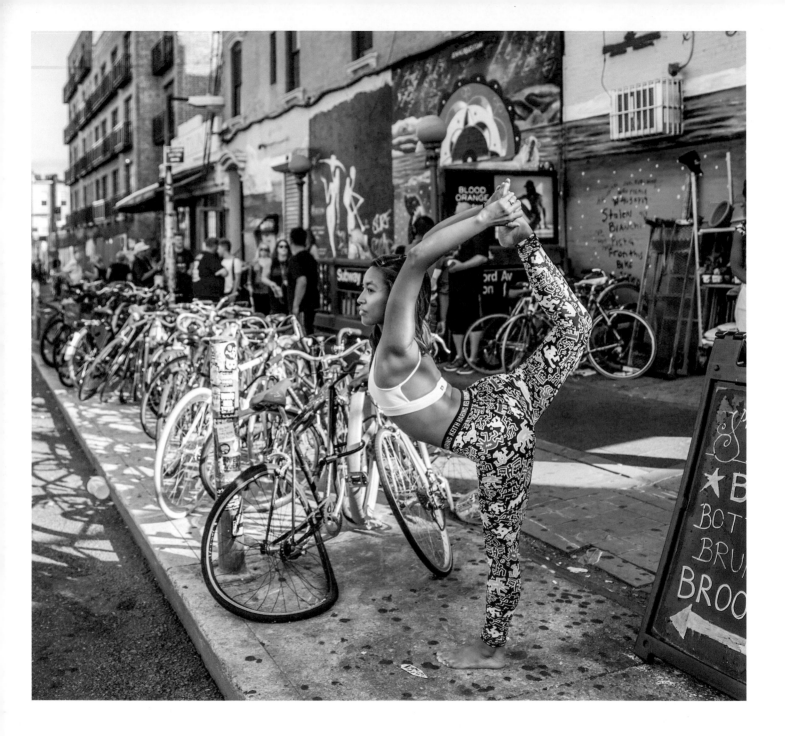

Seek respect
not attention.
It lasts longer

NEW YORK

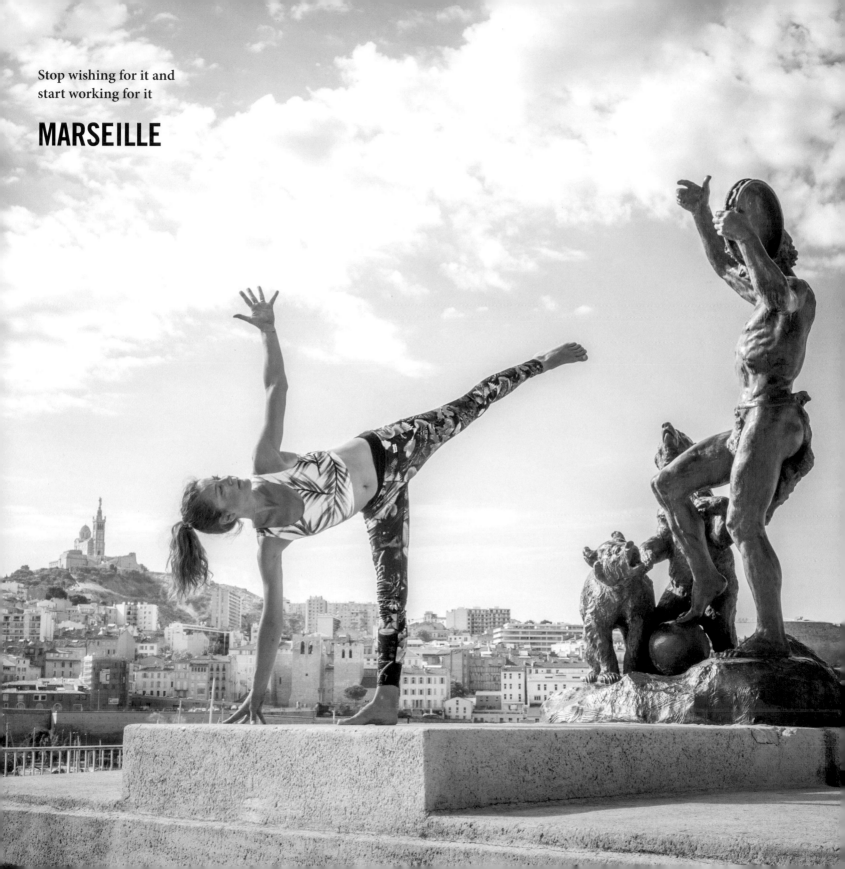

Stop wishing for it and
start working for it

MARSEILLE

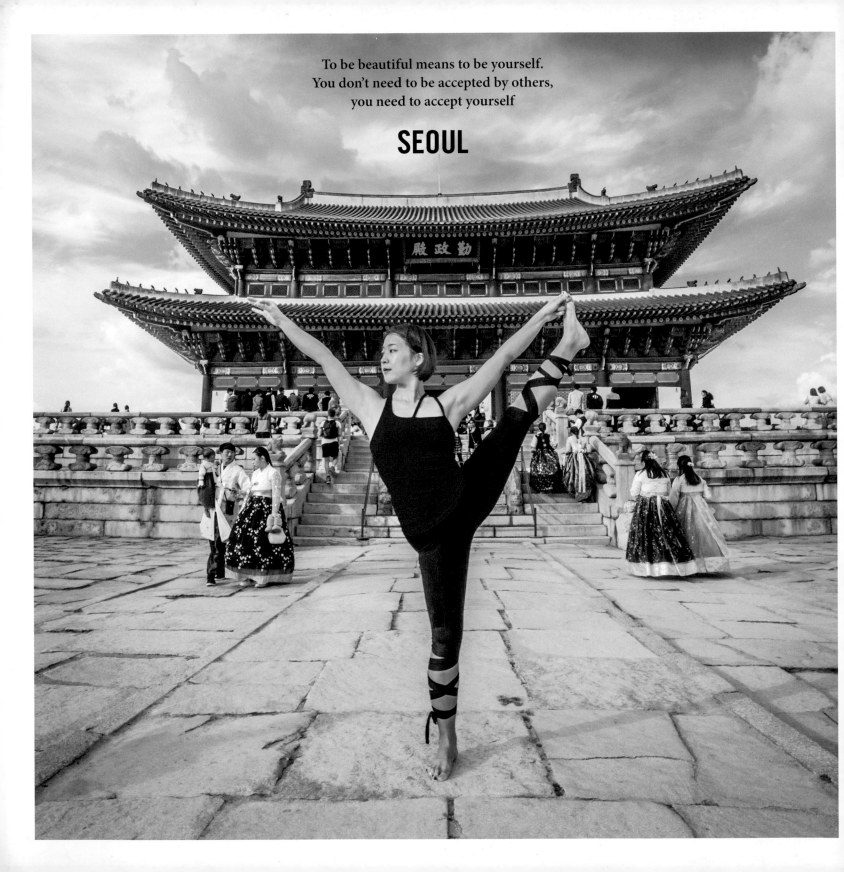

To be beautiful means to be yourself.
You don't need to be accepted by others,
you need to accept yourself

SEOUL

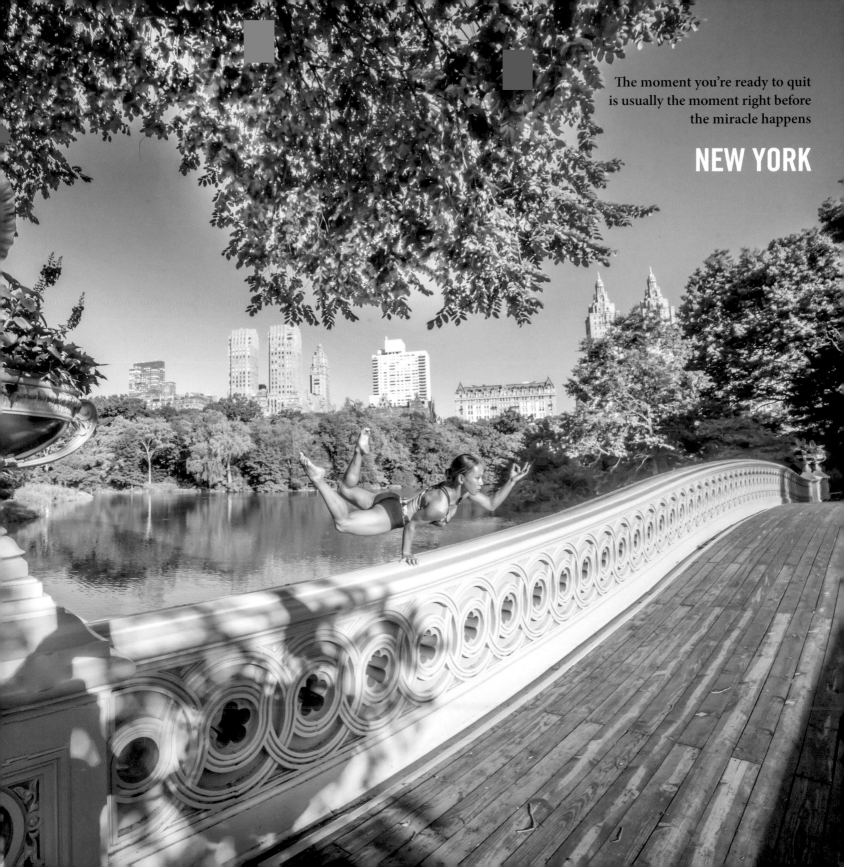

The moment you're ready to quit is usually the moment right before the miracle happens

NEW YORK

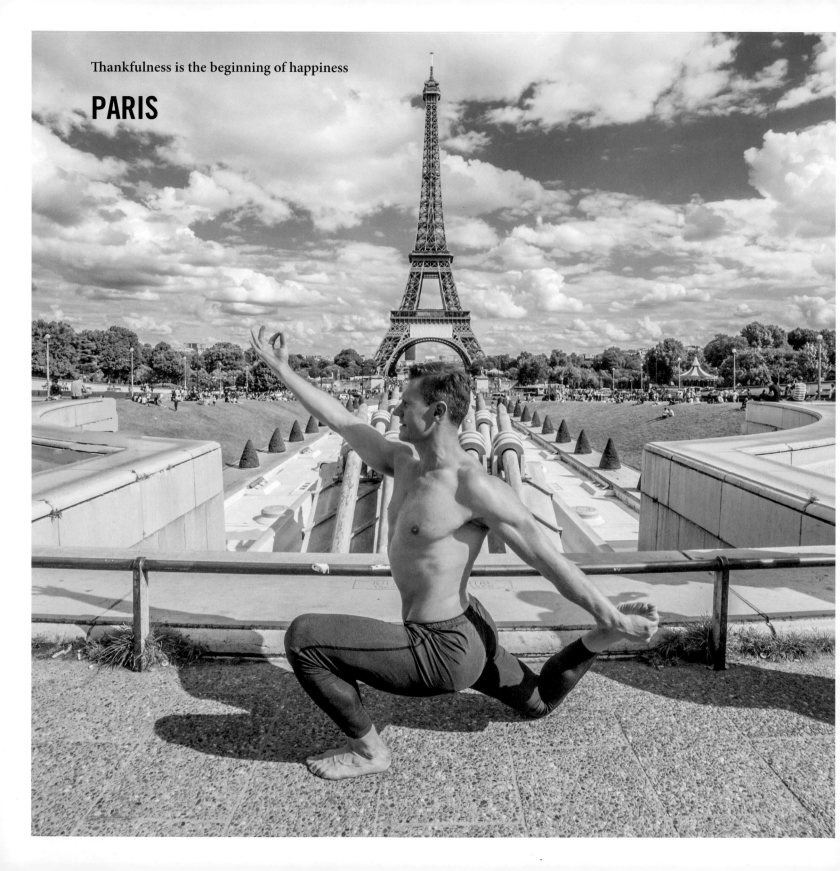

Thankfulness is the beginning of happiness

PARIS

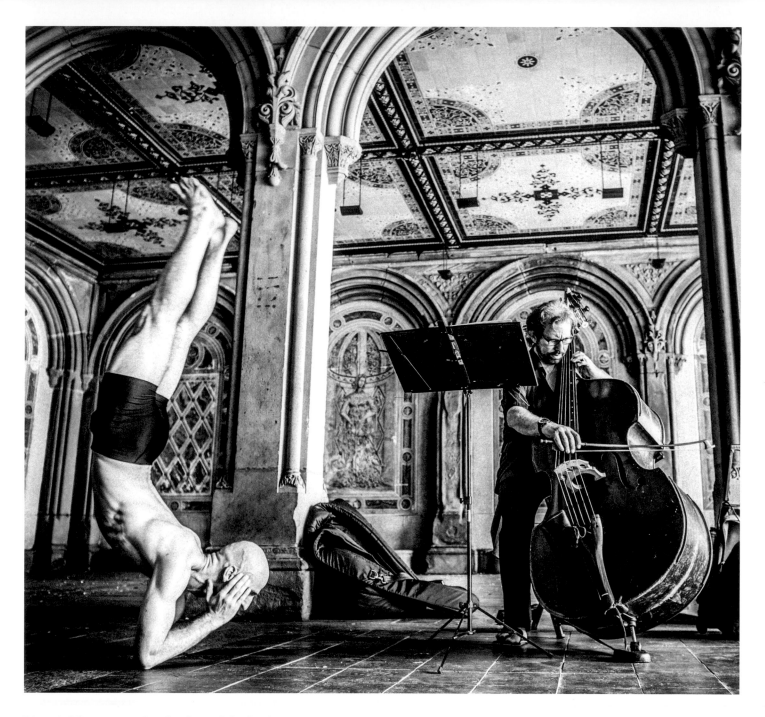

Yoga is like music: the rhythm of the body,
the melody of the mind,
and the harmony of the soul creates
the symphony of life

NEW YORK

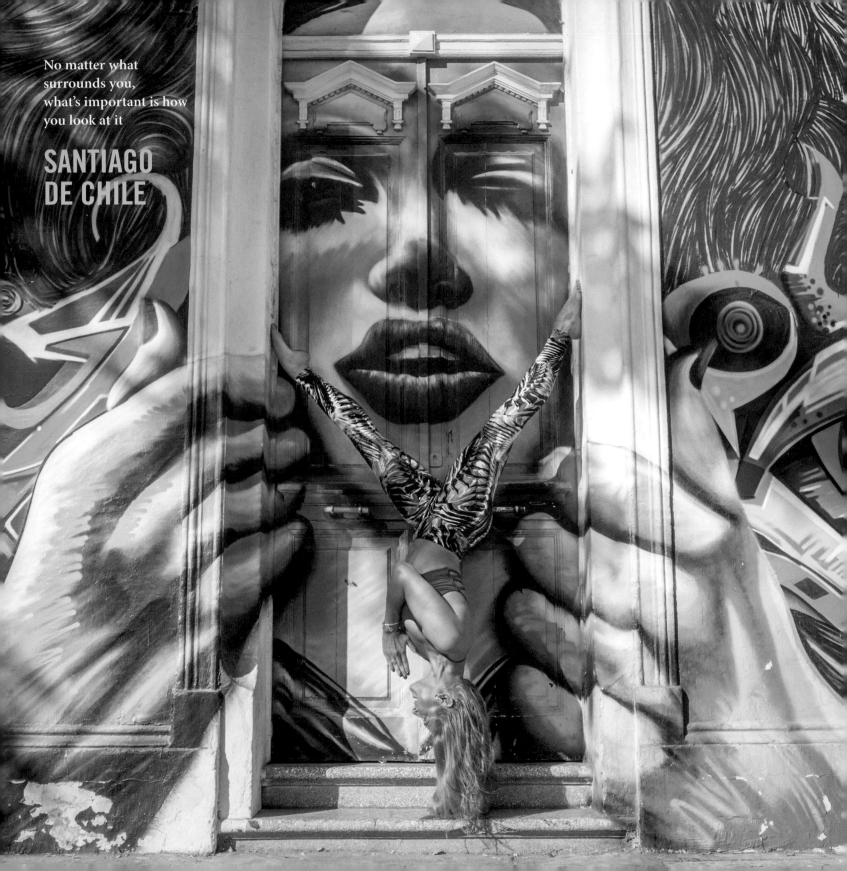

No matter what
surrounds you,
what's important is how
you look at it

SANTIAGO
DE CHILE

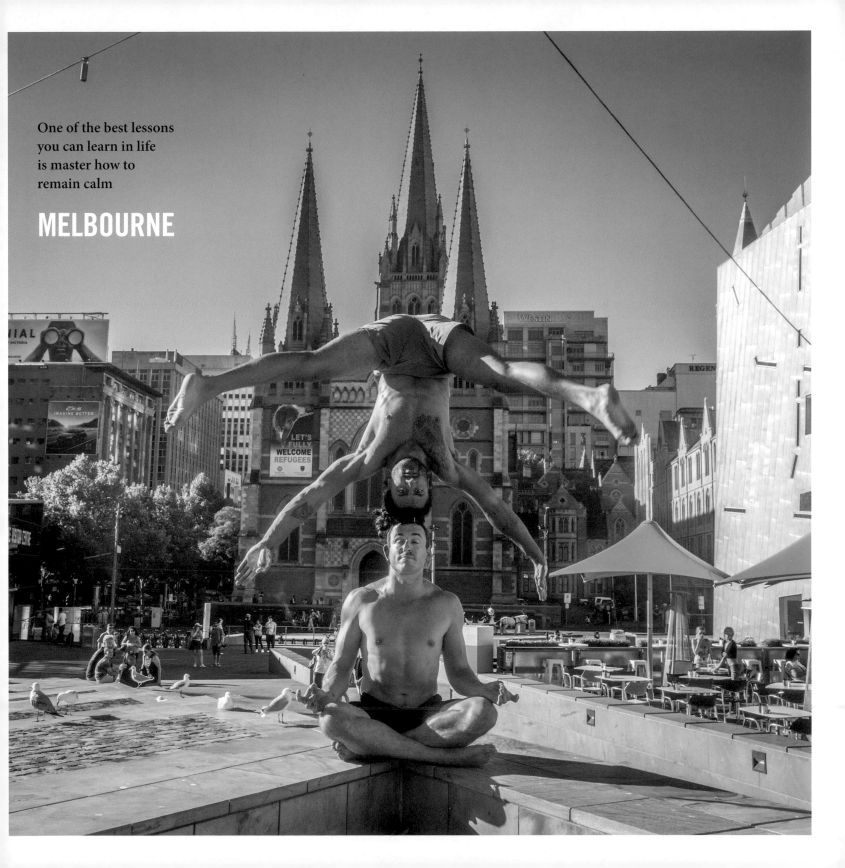

One of the best lessons
you can learn in life
is master how to
remain calm

MELBOURNE

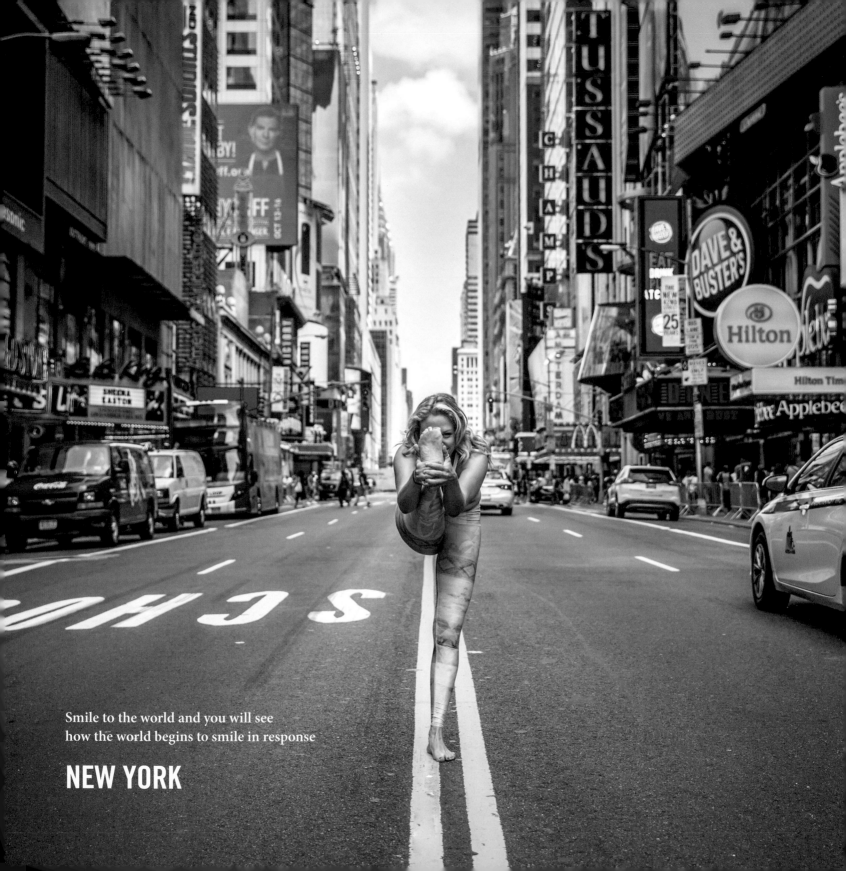

Smile to the world and you will see
how the world begins to smile in response

NEW YORK

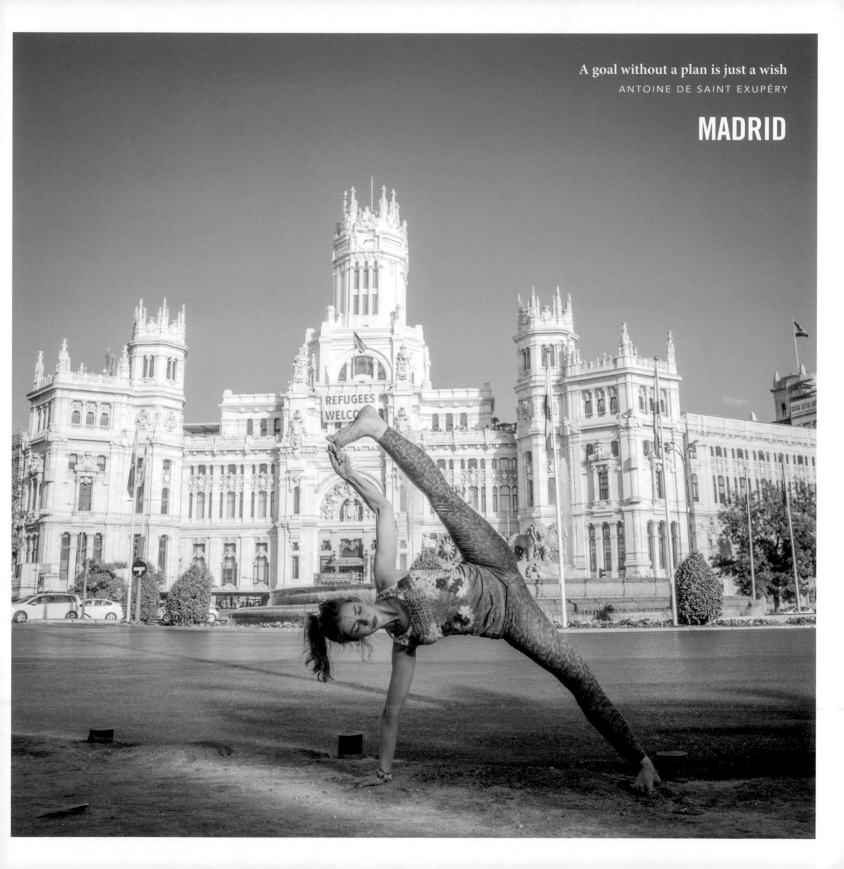

A goal without a plan is just a wish

ANTOINE DE SAINT EXUPÉRY

MADRID

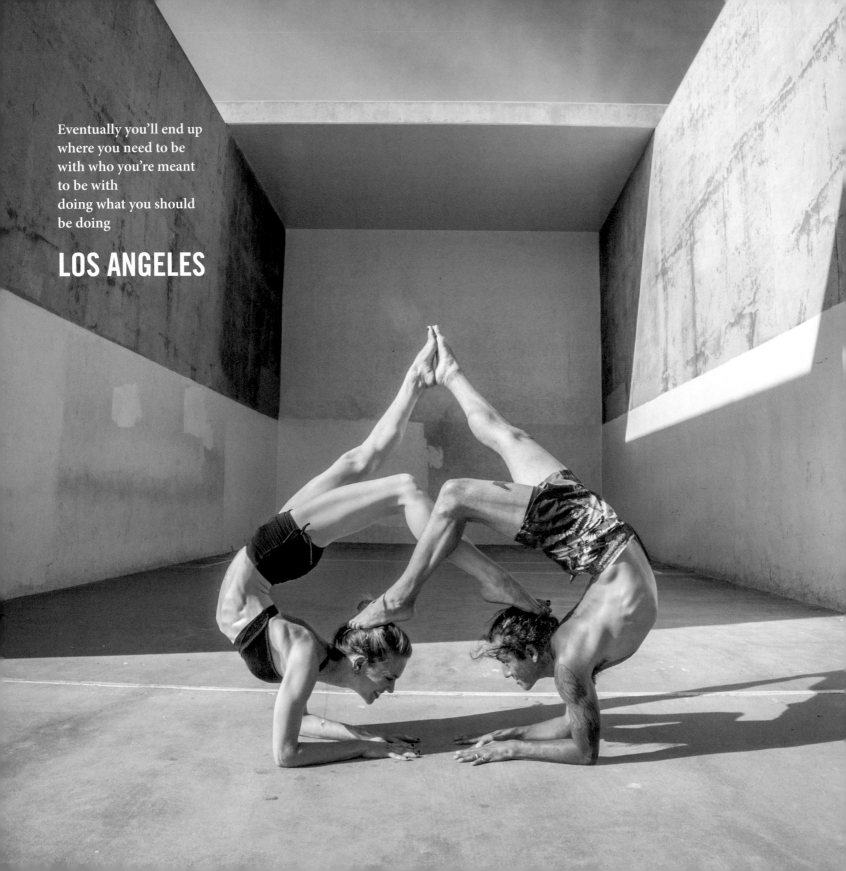

Eventually you'll end up
where you need to be
with who you're meant
to be with
doing what you should
be doing

LOS ANGELES

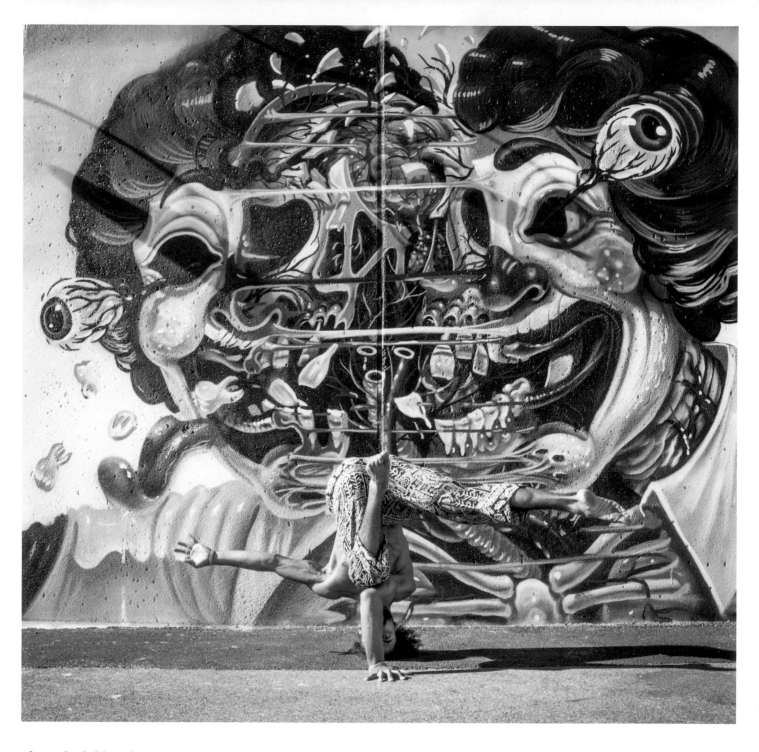

If you don't like what you get
change what you give

NEW YORK

Sometimes you have to let life turn you upside down
so you can learn how to live
right-side up

NICE

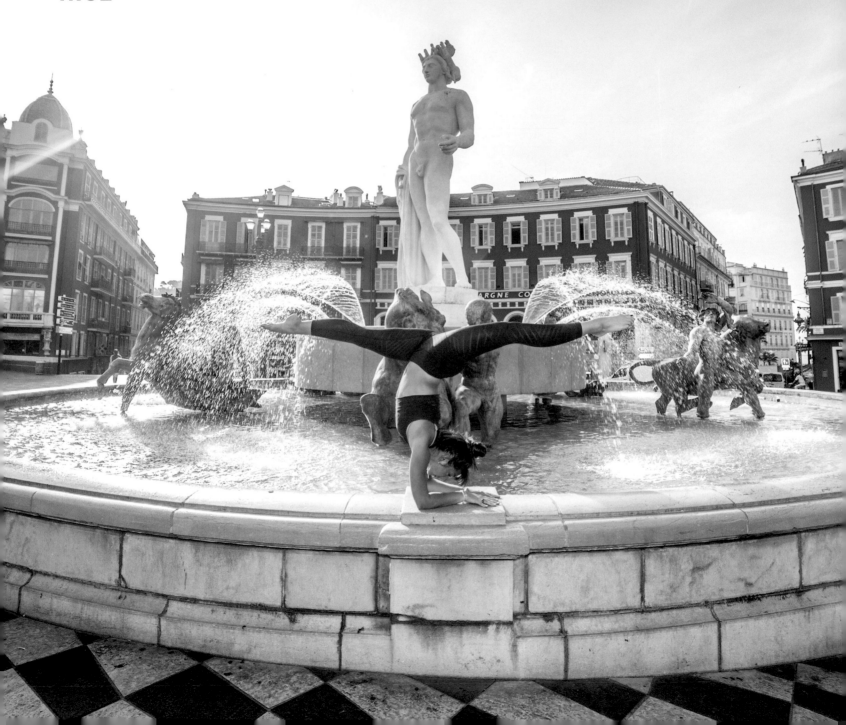

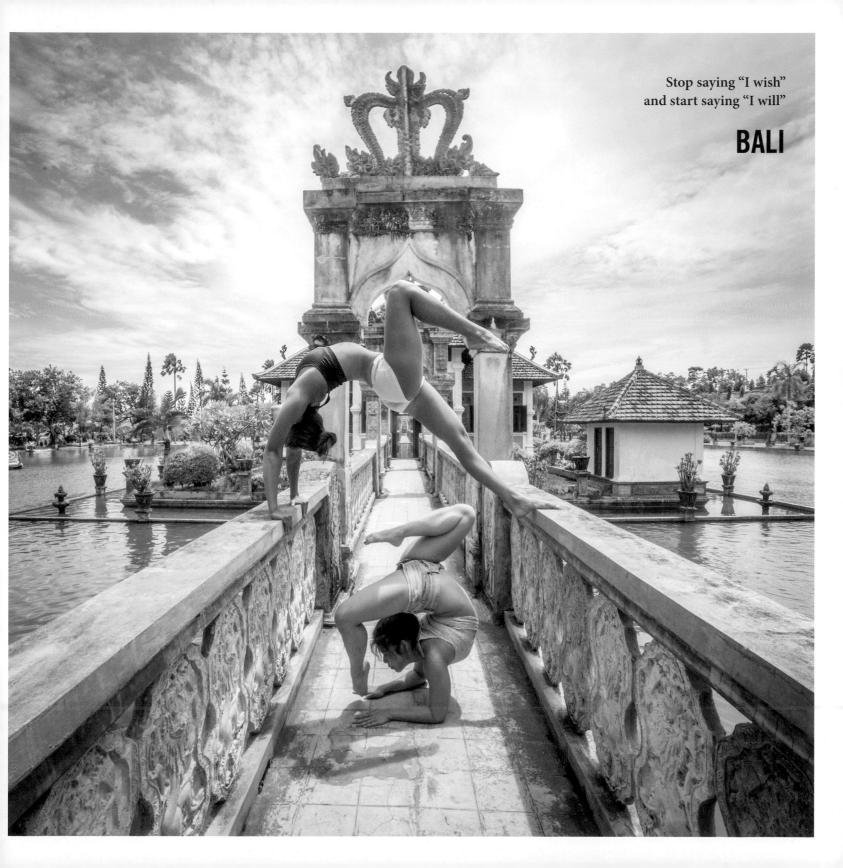

Stop saying "I wish"
and start saying "I will"

BALI

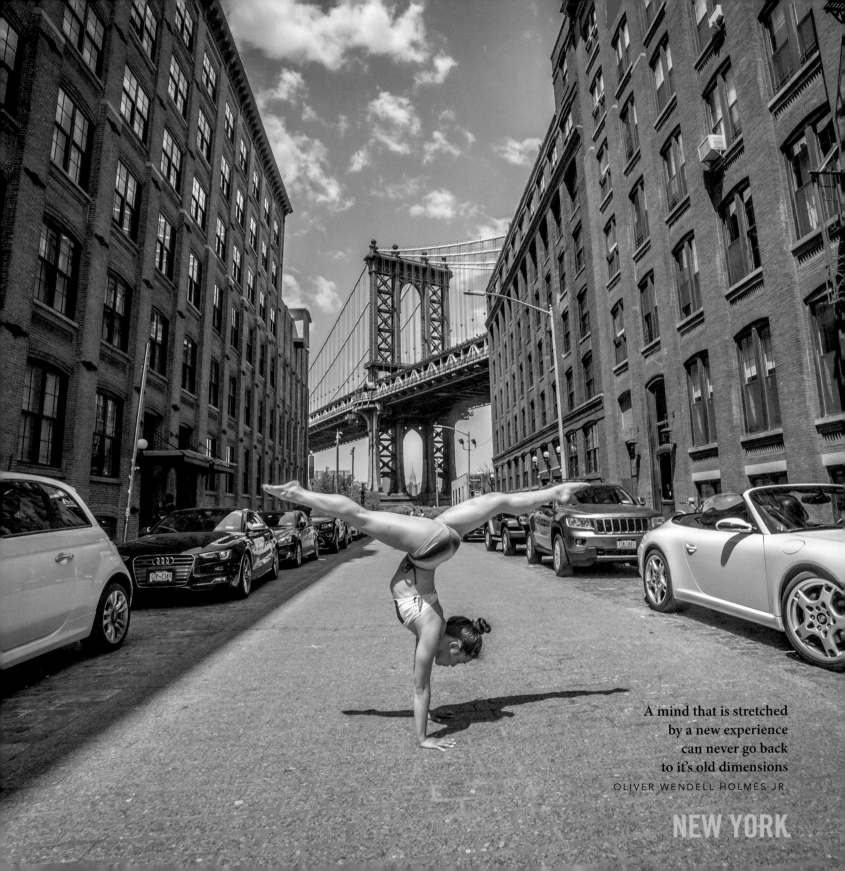

A mind that is stretched
by a new experience
can never go back
to it's old dimensions

OLIVER WENDELL HOLMES JR.

NEW YORK

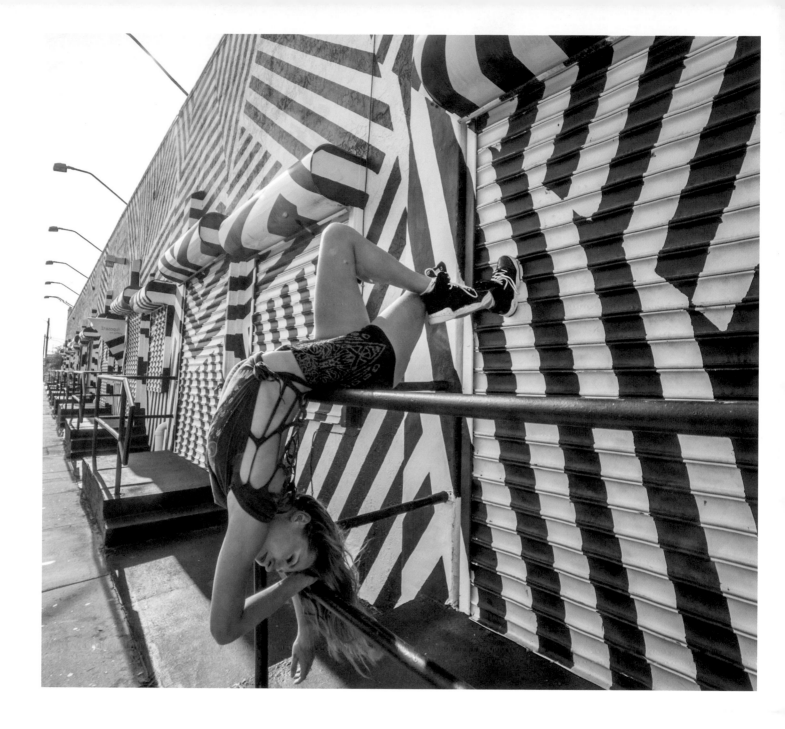

Let your dreams stay big
and your worries stay small RASCAL FLATTS

MIAMI

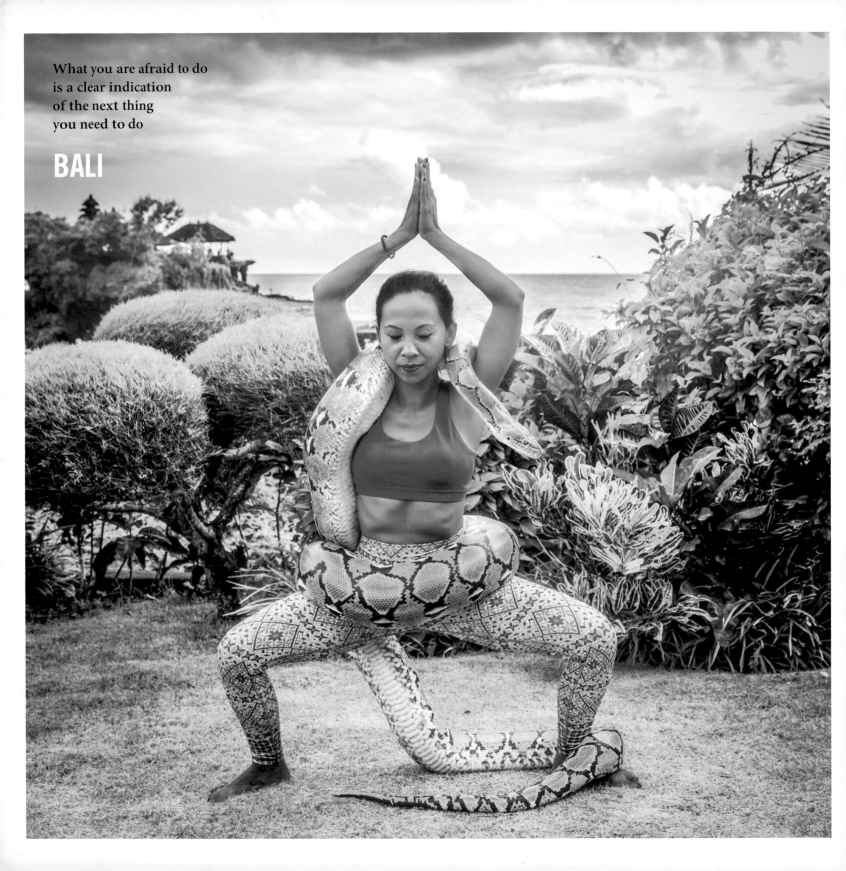

What you are afraid to do
is a clear indication
of the next thing
you need to do

BALI

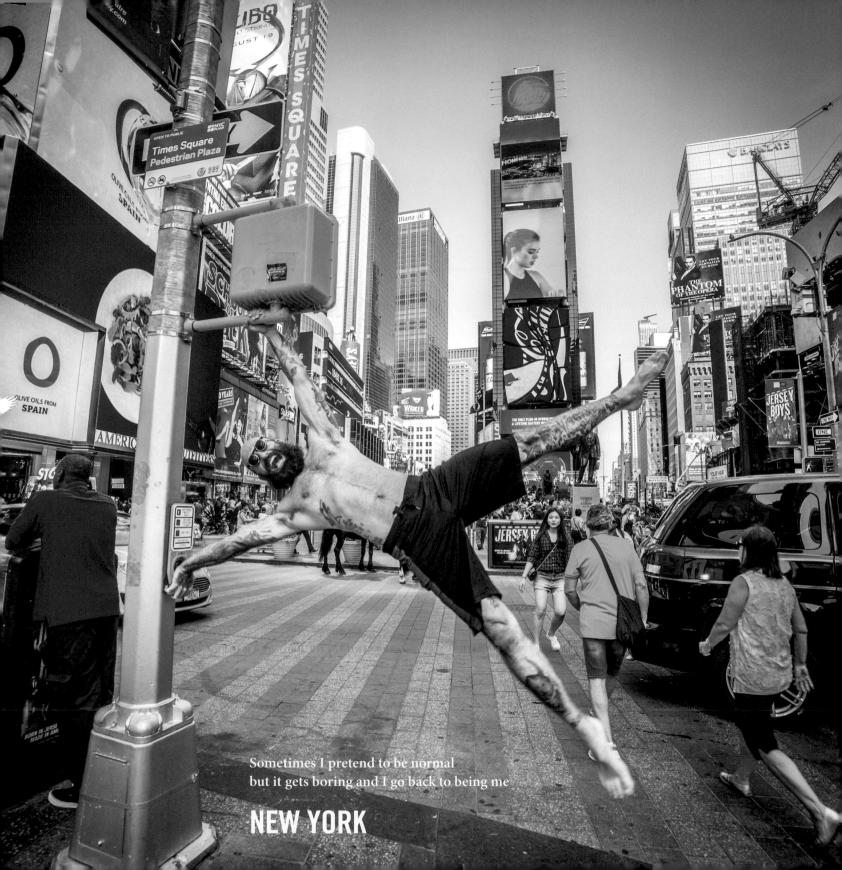

Sometimes I pretend to be normal
but it gets boring and I go back to being me

NEW YORK

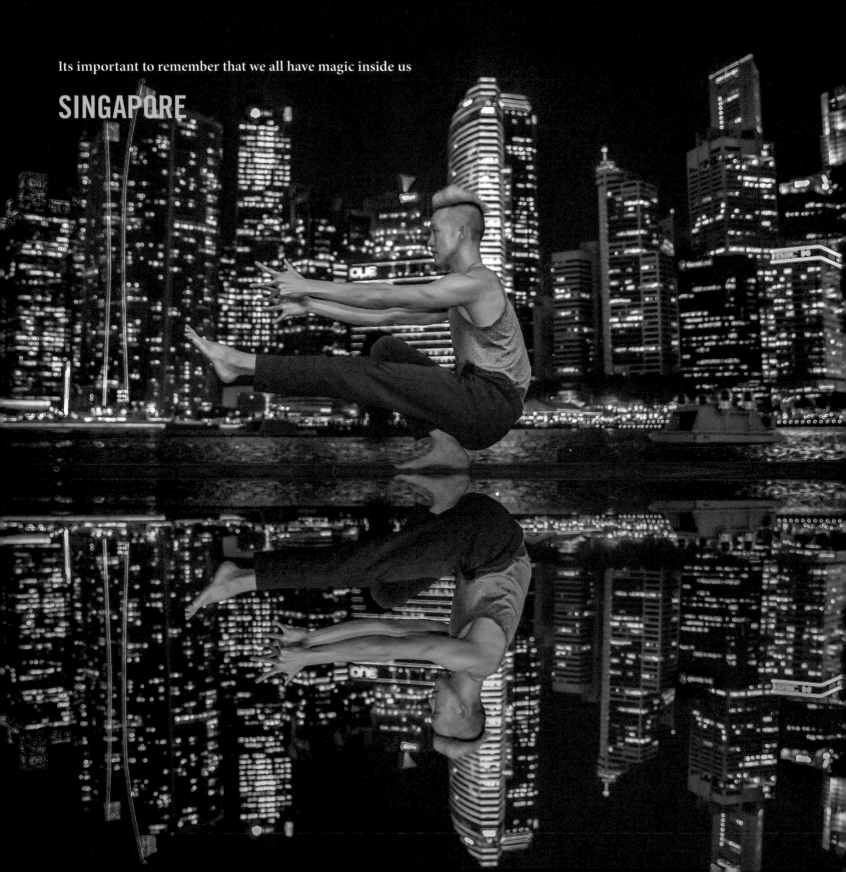

Its important to remember that we all have magic inside us

SINGAPORE

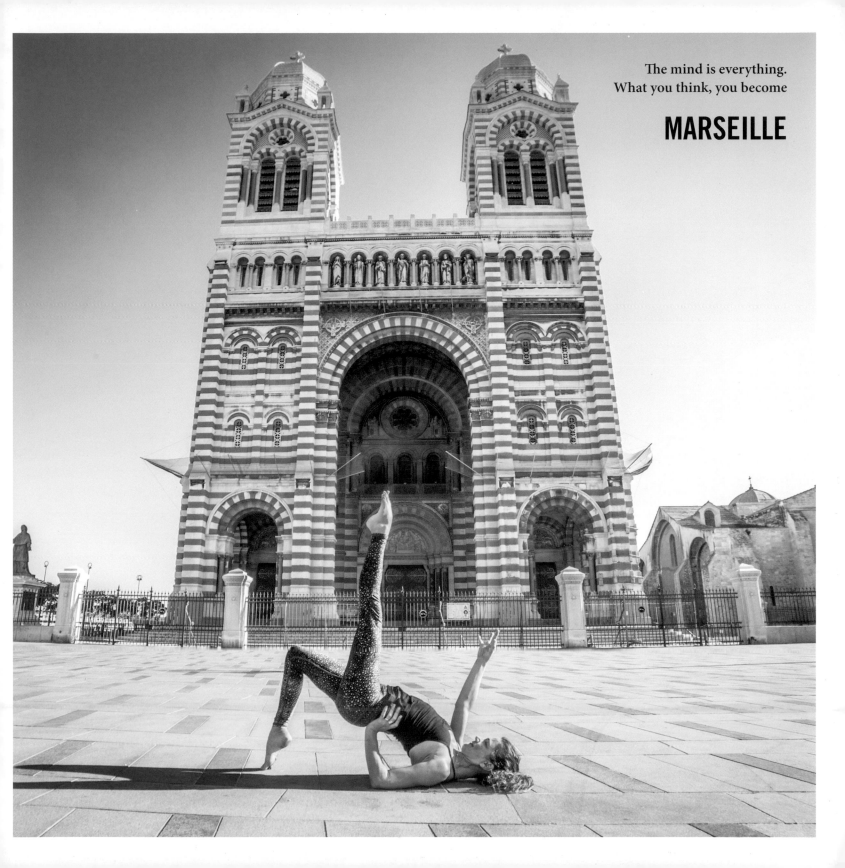

The mind is everything.
What you think, you become

MARSEILLE

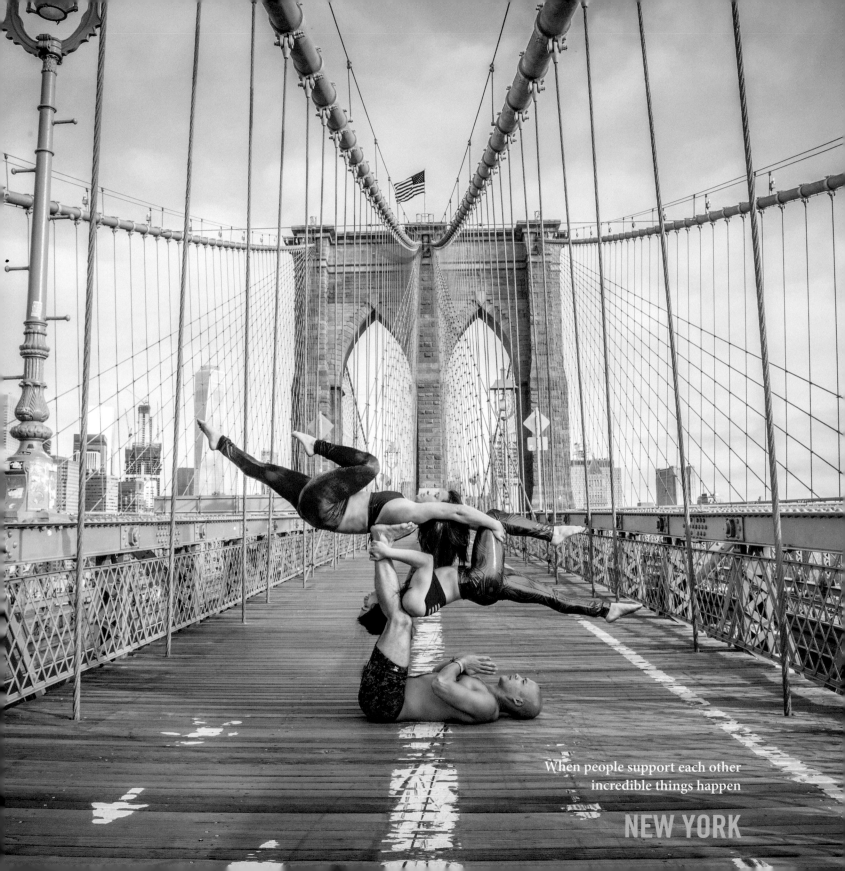

When people support each other
incredible things happen

NEW YORK

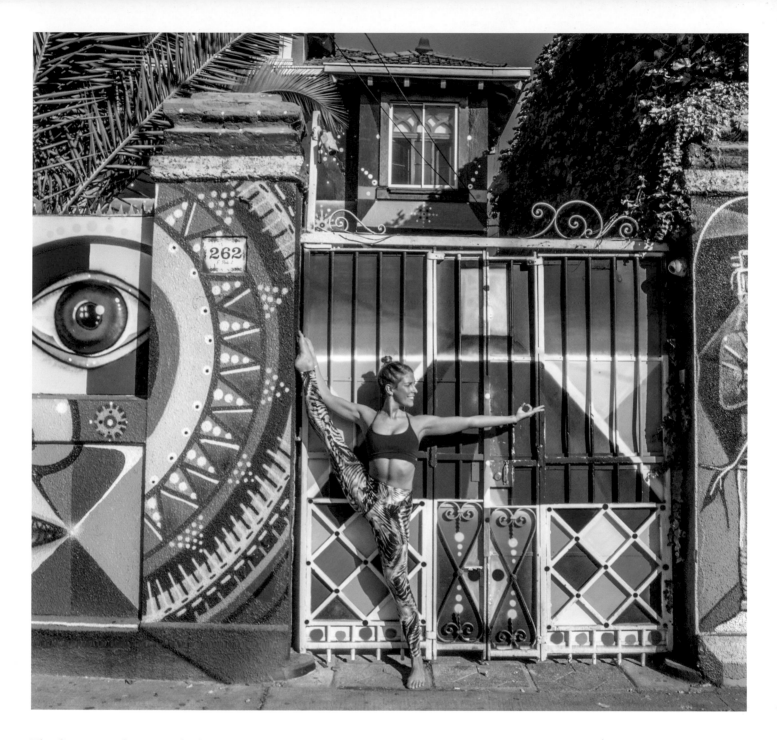

The first to apologize is the bravest,
the first to forgive is the strongest,
the first to forget is the happiest

SANTIAGO DE CHILE

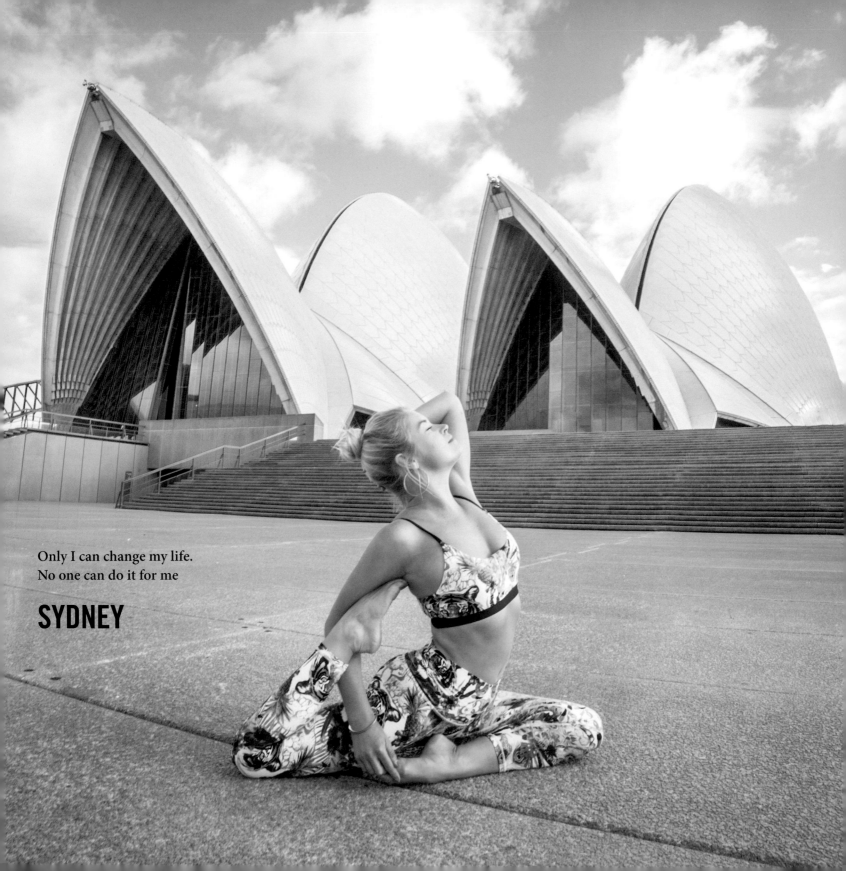

Only I can change my life.
No one can do it for me

SYDNEY

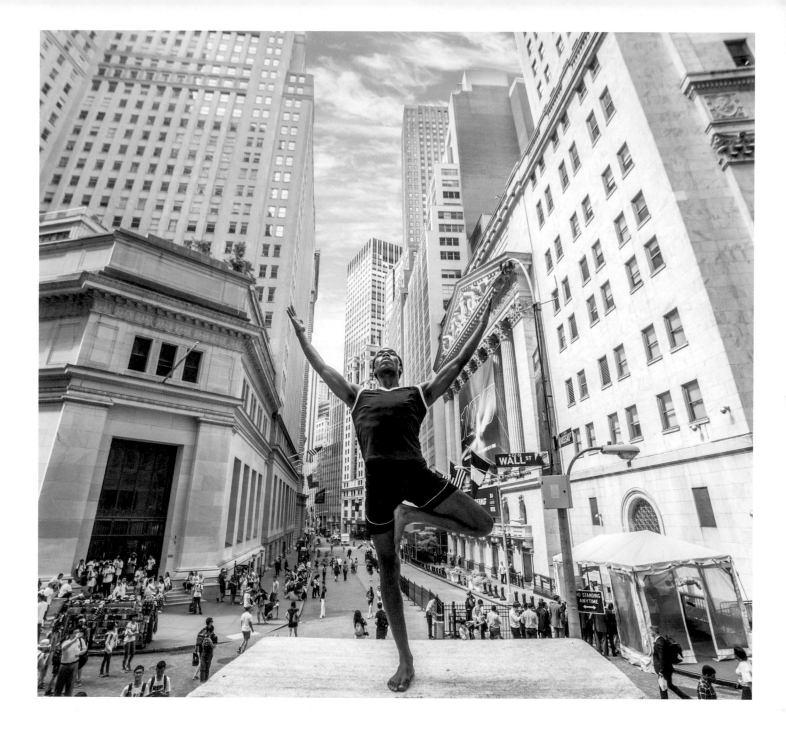

If you want to feel rich
just count all gifts you have
that money can't buy

NEW YORK

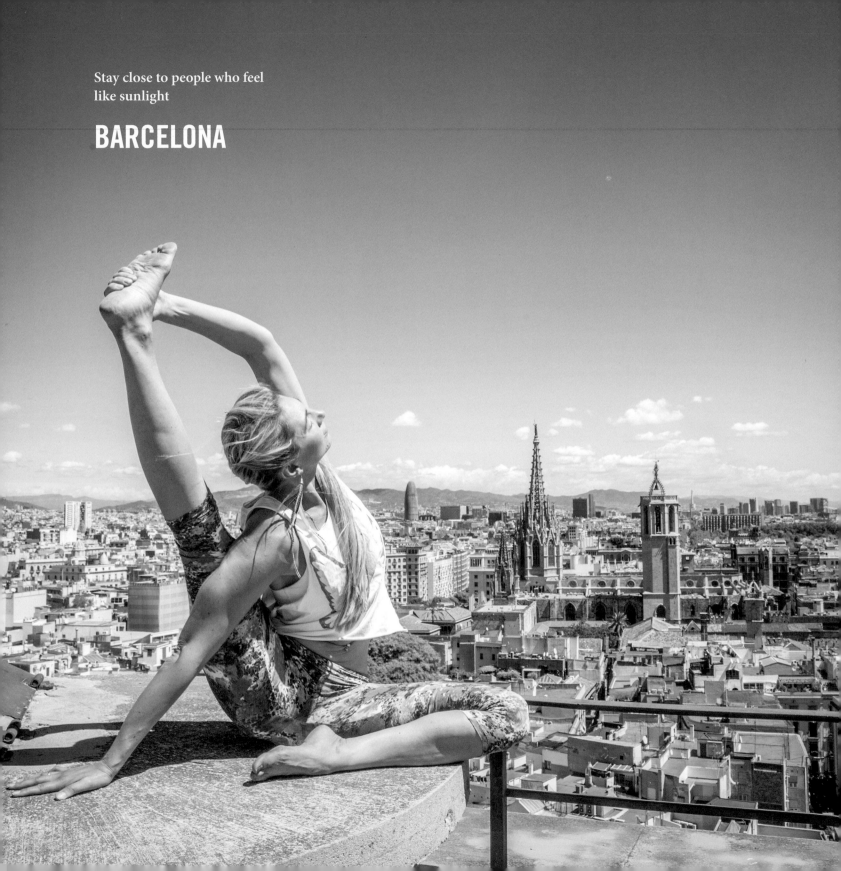

Stay close to people who feel like sunlight

BARCELONA

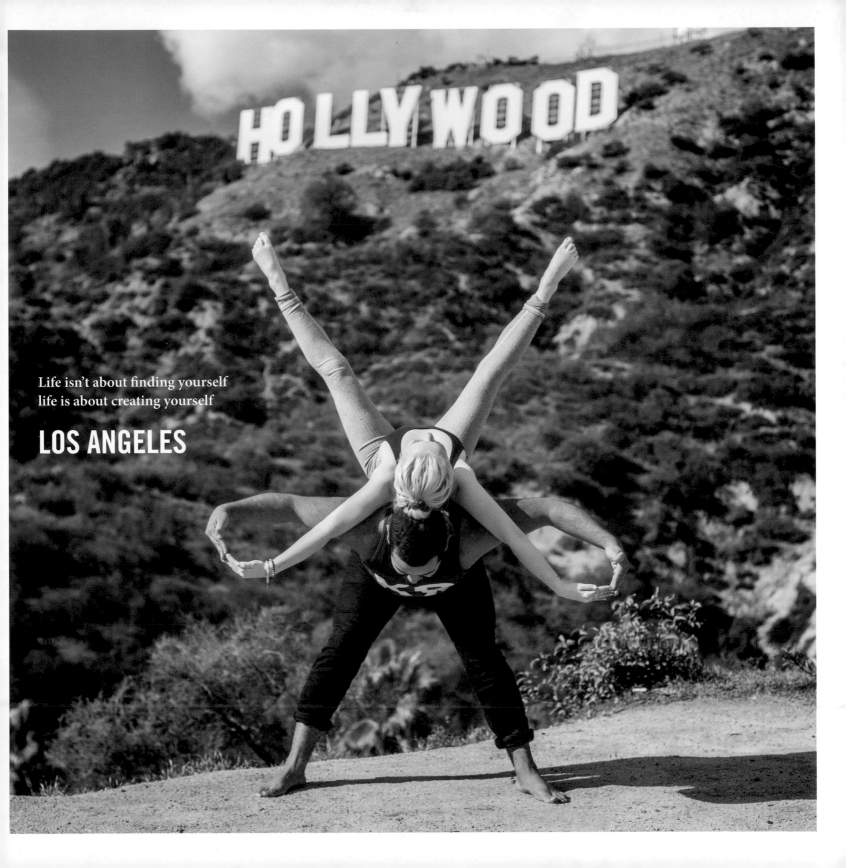

Life isn't about finding yourself
life is about creating yourself

LOS ANGELES

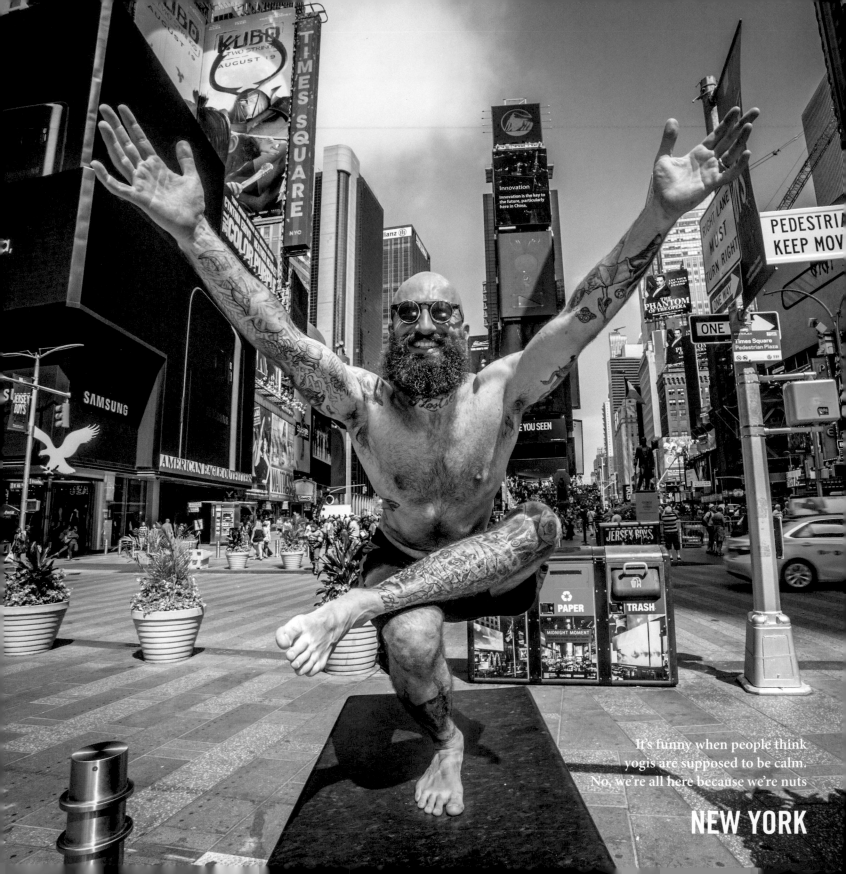

It's funny when people think
yogis are supposed to be calm.
No, we're all here because we're nuts

NEW YORK

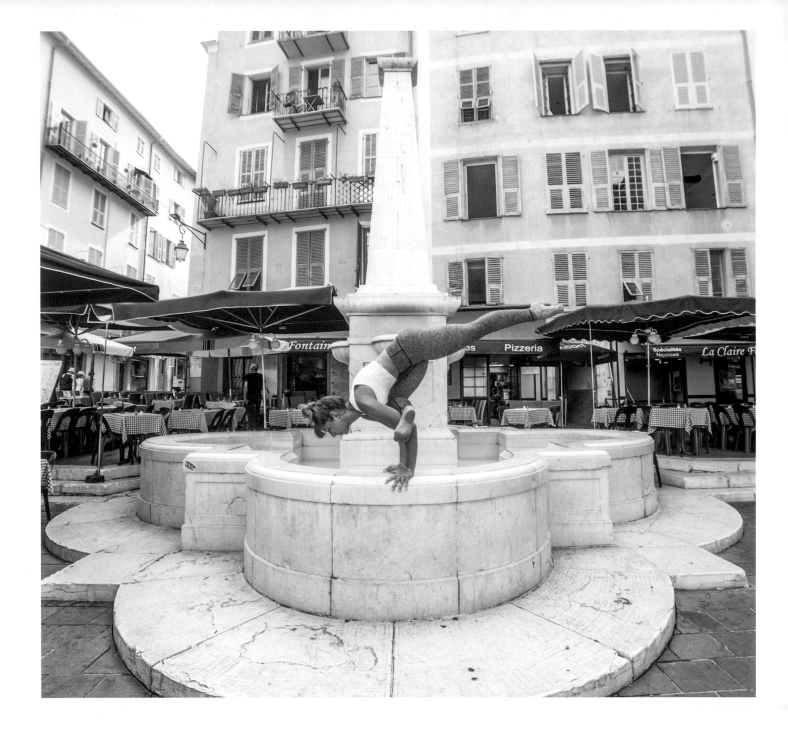

First month pain,
second month tired,
third month flying

NICE

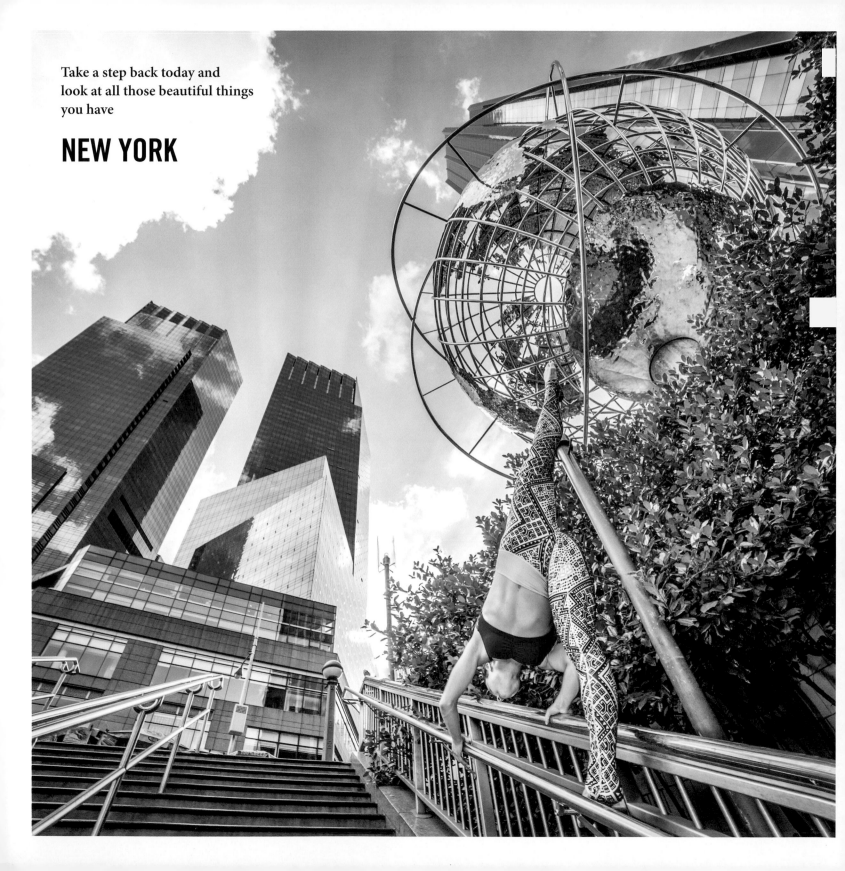

Take a step back today and look at all those beautiful things you have

NEW YORK

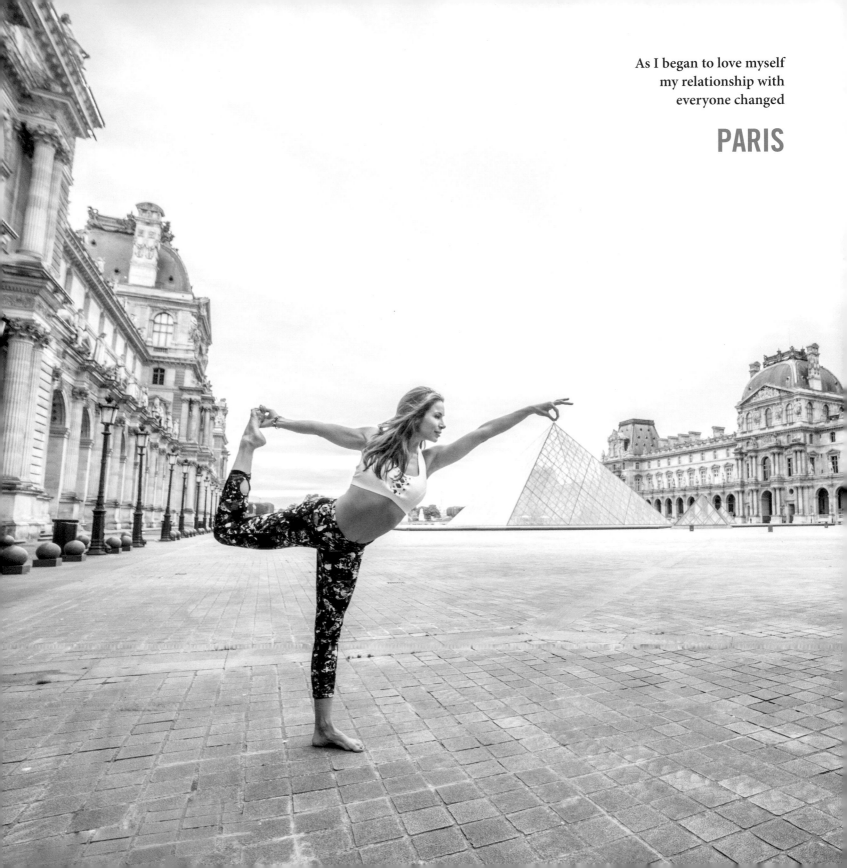

As I began to love myself
my relationship with
everyone changed

PARIS

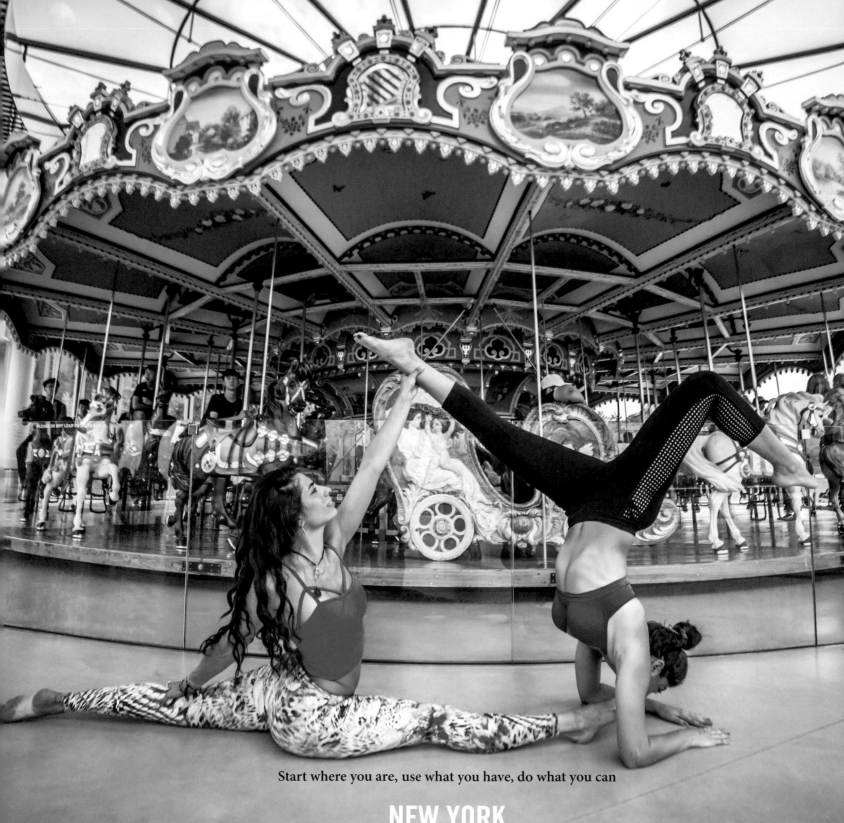

Start where you are, use what you have, do what you can

NEW YORK

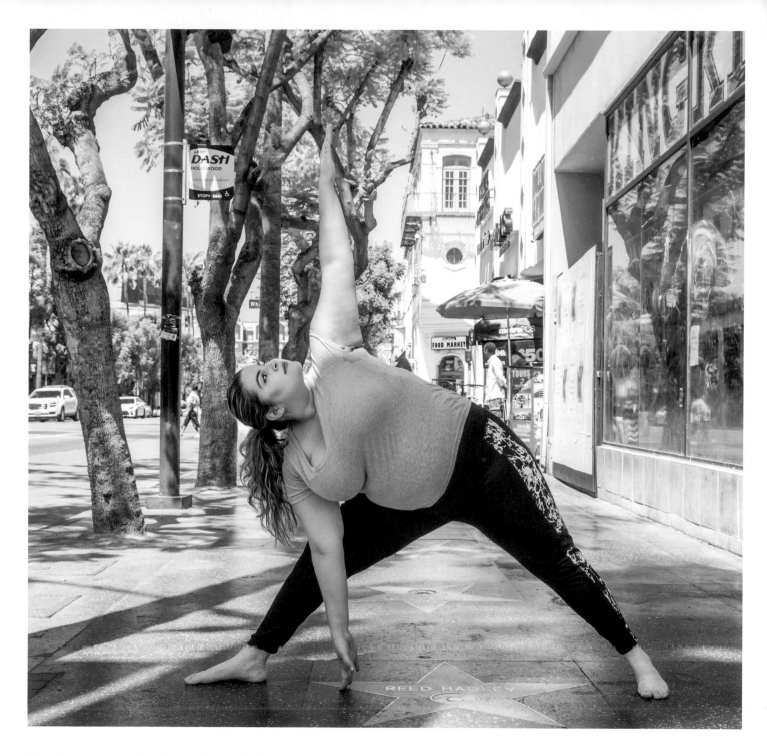

Yoga is not about the shape of your body,
is about the shape of your life

LOS ANGELES

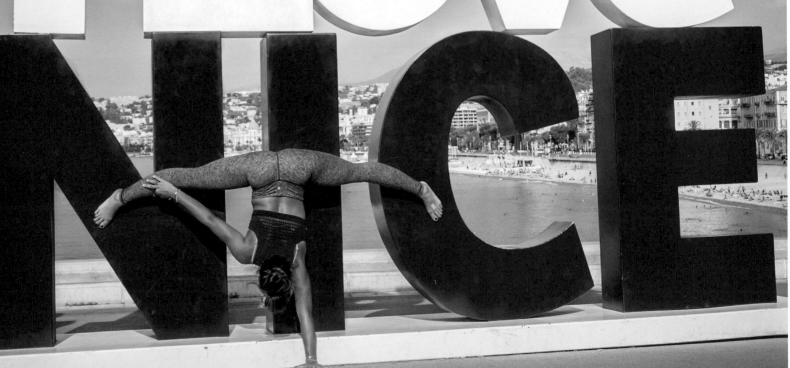

We lose ourselves in the things we love.
We find ourselves there too

NICE

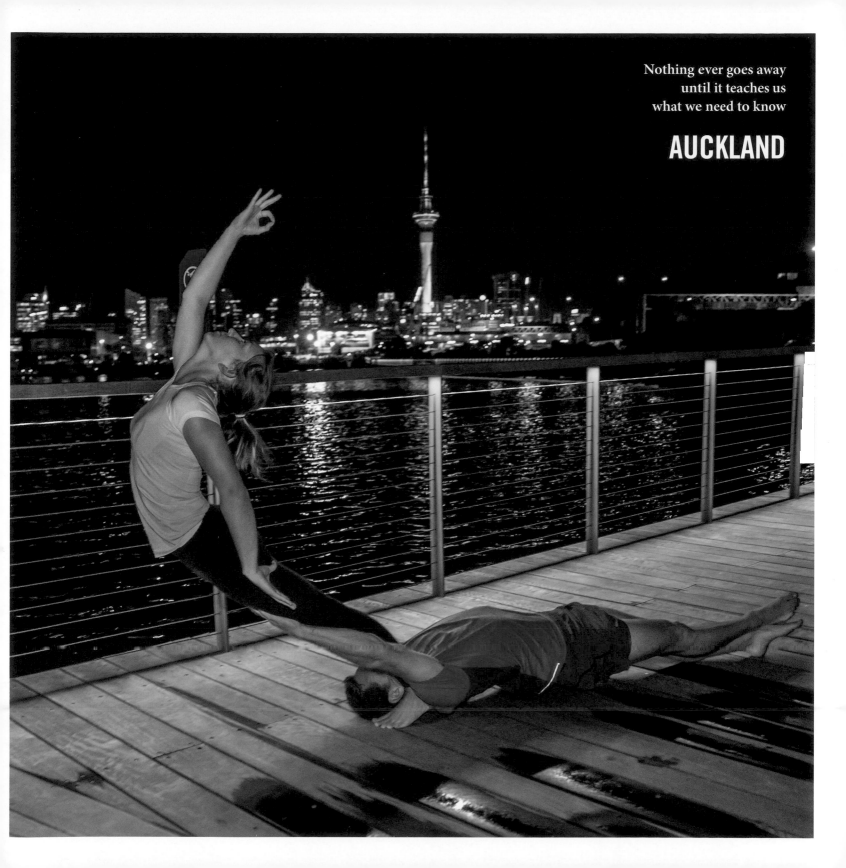

Nothing ever goes away
until it teaches us
what we need to know

AUCKLAND

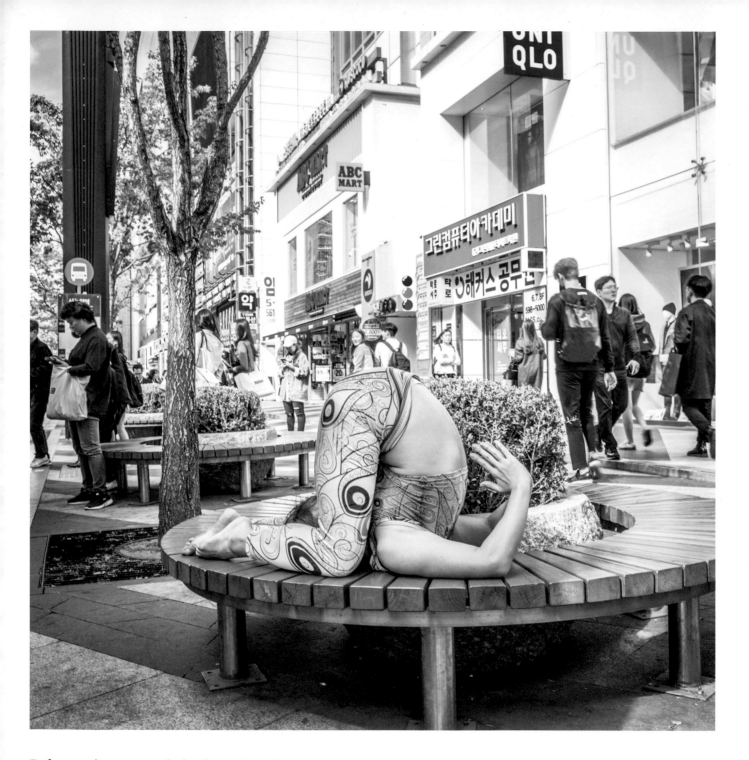

Before you've practiced, the theory is useless.
After you've practiced, the theory is obvious

SEOUL

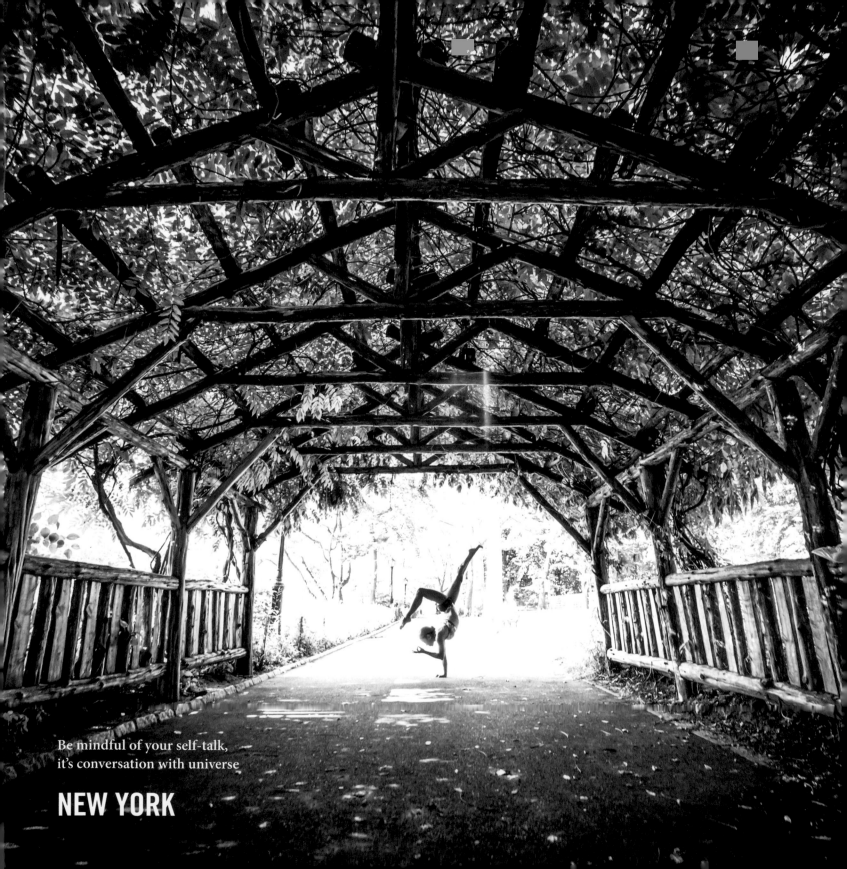

Be mindful of your self-talk,
it's conversation with universe

NEW YORK

Goff Books
Published by Goff Books. An Imprint of ORO Editions
Gordon Goff: Publisher

www.goffbooks.com
info@goffbooks.com

Photography by Alexey Wind
Book Design by Pablo Mandel / CircularStudio.com
Managing Editor: Jake Anderson

Typeset in ASAP, Trade Gothic, and Minon

10 9 8 7 6 5 4 3 2 1 First Edition

ISBN: 978-1-940743-76-9

Color Separations and Printing: ORO Group Ltd.
Printed in China.

Goff Books makes a continuous effort to minimize the overall carbon
footprint of its publications. As part of this goal, Goff Books, in
association with Global ReLeaf, arranges to plant trees to replace
those used in the manufacturing of the paper produced for its books.
Global ReLeaf is an international campaign run by American Forests,
one of the world's oldest nonprofit conservation organizations. Global
ReLeaf is American Forests' education and action program that helps
individuals, organizations, agencies, and corporations improve the
local and global environment by planting and caring for trees.